INSOMNIAC CITY

BILL HAYES

NEW YORK, OLIVER, AND ME

BLOOMSBURY

NEW YORK · LONDON · OXFORD · NEW DELHI · SYDNEY

Bloomsbury USA
An imprint of Bloomsbury Publishing Plc

1385 Broadway 50 Bedford Square
New York London
NY 10018 WC1B 3DP
USA UK

www.bloomsbury.com

BLOOMSBURY and the Diana logo are trademarks of Bloomsbury Publishing Plc

First published 2017

© Bill Hayes 2017

Photographs © Bill Hayes 2017

Author's note: some of the names in this book have been changed to protect the privacy
of persons involved. Versions of some chapters in this book previously appeared in the
New York Times and in the *Virginia Quarterly Review*.

ISBN: HC: 978-1-62040-493-5
 ePub: 978-1-62040-495-9

Library of Congress Cataloging-in-Publication Data is available.

2 4 6 8 10 9 7 5 3

Designed by Elizabeth Van Itallie
Typeset by RefineCatch Limited, Bungay, Suffolk
Printed and bound by CPI Group (UK) Ltd, Croydon, CR0 4YY

To find out more about our authors and books visit www.bloomsbury.com. Here you
will find extracts, author interviews, details of forthcoming events and the option to sign
up for our newsletters.

Bloomsbury books may be purchased for business or promotional use. For information
on bulk purchases please contact Macmillan Corporate and Premium Sales Department
at specialmarkets@macmillan.com.

For Nancy Miller,
and in memory of Oliver

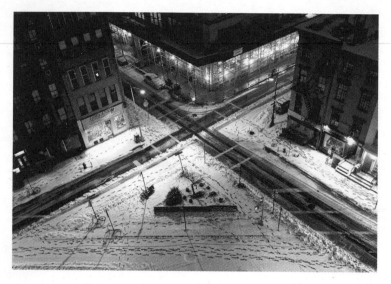

Cross Streets with Snow

CONTENTS

PART III: HOW NEW YORK BREAKS YOUR HEART

"I don't so much fear death as I do wasting life."
Oliver Sacks

PART I

INSOMNIAC
CITY

INSOMNIAC CITY

I moved to New York eight years ago and felt at once at home. In the haggard buildings and bloodshot skies, in trains that never stopped running like my racing mind at night, I recognized my insomniac self. If New York were a patient, it would be diagnosed with *agrypnia excitata*, a rare genetic condition characterized by insomnia, nervous energy, constant twitching, and dream enactment—an apt description of a city that never sleeps, a place where one comes to reinvent himself.

I had brought very little with me from San Francisco, my home for twenty-five years, in part because I wished to leave behind any reminders of the life I'd had there, but also for more practical reasons. My new apartment was a virtual tree house, a tiny top-floor walk-up at eye level with the ailanthus boughs. There was not room for more than a desk, a chair, a mattress. Nor a need: You see, the place came furnished with spectacular views of Manhattan.

What I didn't know when I rented the place was that the French restaurant located straight below my apartment had outdoor seating till two A.M. Lying awake in bed, I could literally hear glasses clinking and toasts being made, six stories down. This was irritating at first. But

it wasn't long before I discovered a phenomenon heretofore unknown to me: Laughter rises. Hearing happy, laughing people is no cure for insomnia but has an ameliorative effect on brokenheartedness.

Sometimes I'd sit in the kitchen in the dark and gaze out at the Empire State and Chrysler buildings. Such a beautiful pair, so impeccably dressed, he in his boxy suit, every night a different hue, and she, an arm's length away, in her filigreed skirt the color of the moon. I regarded them as an old married couple, calmly, unblinkingly keeping watch over one of their newest sons. And I returned the favor; I would be there the moment the Empire State turned off its lights for the night as if to get a little shut-eye before sunrise.

Here's another wonder I discovered about life here: In the summertime, late into the night, some leave behind their sweat-dampened sheets to read in the coolness of a park under streetlights. Not Kindles, mind you, or iPhones. But books. Newspapers. Novels. Poetry. Completely absorbed, as if in their own worlds. As indeed, they are. I had never seen anything like this until I took a shortcut through Abingdon Square Park one night while walking off my own mild *agrypnia*.

First I saw an old man reading a newspaper from which someone (his wife?) had snipped numerous articles; it looked like a badly botched doily. I tiptoed past, as if wearing slippers, and he, as if at home in his La-Z-Boy, did not glance up.

Next I spotted a young man reading a paperback with a distinctive brick-red cover. I was pretty certain I knew what classic he had in hand but had to make sure. I fake-dropped my keys nearby and crouched down for a better look. Just then, the young man shifted in his seat, denying me absolute proof. That's okay. I was left to imagine him imagining himself as Holden Caulfield.

At the far end of the park, I found a middle-aged woman bathed in a light Vermeer would have loved, reading what looked like a textbook. Was she a teacher preparing for tomorrow's class, a student cramming last-minute, or neither of these? Perhaps she was simply teaching herself.

Of course, not everyone awake at this hour is an insomniac. The city is alive with doormen, delivery boys on bikes, street sweepers, homeless people, hustlers, prep cooks popping up out of trap doors in the sidewalk. I make a point of waving or nodding hello when I can. I have come to believe that kindness is repaid in unexpected ways and that if you are lonely or bone-tired or blue, you need only come down from your perch and step outside. New York—which is to say, New Yorkers—will take care of you.

One night I was walking down Hudson Street, on my way home from a friend's, when I spotted a dollar bill on the sidewalk. Even at my age, such a find seemed magical. Free money! I leaned down to pick it up just as a woman opposite me was doing the same thing: "A dollar," I heard her murmur, and our heads practically bumped. We both laughed. I happened to reach it first, but it seemed ungentlemanly to take it. "Here, it's yours," I said, offering it to the woman.

"No! No, it's yours, you got it first."

"No, I insist, you take it," I said, but by this point she was walking away, arm in arm with a handsome man; she already had her prize. Suddenly, inspiration struck: "I'm going to leave it for someone else!" I called back to her.

"Perfect!" she said, over her shoulder. "Good night!"

I dropped the dollar back onto the sidewalk. It was liberating: To throw money away or, more accurately, throw it to the fates, as I had with my life by moving to New York City at age forty-eight.

I walked a few steps and, I kid you not, hid behind a tree to watch what would take place. One couple passed by without noticing the dollar, then another. Finally, a man about my age came walking in my direction. Hunched shoulders, troubled look, pulling on a cigarette. Definitely an insomniac, I thought. *I want you to have it. It's yours. You deserve it.*

From my secluded vantage point, I watched as the fellow spotted the dollar. He stopped, looked around to see if anyone was in the vicinity. Perhaps someone in front of him had dropped it? No, the sidewalk was empty. He picked up the dollar and pocketed it with a small smile, then went on his way. As did I, back to my tree house.

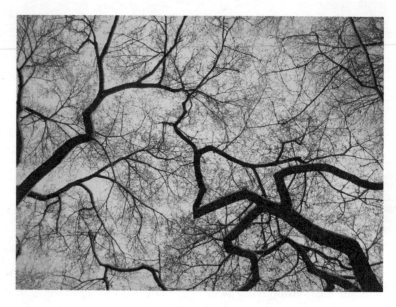

Winter Trees

SLEEP: LOSS

I used to think that the only thing worse than having insomnia was having insomnia next to someone who falls fast asleep and stays soundlessly so till morning.

That was my life for more than sixteen years. In San Francisco I lived with a man who slept, yes, like a baby. There were nights, many nights, when I literally wanted to steal his sleep—slip beneath his eyelids and yank it out of him; a kind of middle-of-the-night *Chien Andalou* moment. Instead, I spent the equivalent of at least a tenth of our relationship lying awake or reading in bed. In the end, that I happened to be in a deep sleep when Steve went into cardiac arrest next to me now seems beyond irony. If I had not taken half a sleeping pill that night ten years ago, might I have been awake and saved him?

I can no longer remember the sound of his laughter but I clearly recall what he looked like while sleeping: his head propped on a scrunched-up pillow, his muscular arms, his breath blown in warm puffs from the corner of his mouth, the place where Popeye's pipe would go. I suppose this is the upside to insomnia. I clocked a lot of time studying Steve in repose.

His death had been as swift as it was inexplicable: He had been only forty-three and remarkably fit, with no history of heart problems. At first, I'd thought he was having a nightmare, but he was thrashing so violently and unable to speak. I called 911, began CPR, EMTs came. I remember how they kept asking me if we'd been doing drugs; the question seemed absurd; Steve was so clean-living, so wholesome really, he never even drank a beer. They got him to an ER just a few blocks away. But by then he was gone.

My upstairs neighbor had heard the commotion and gotten herself to the hospital. Vicki virtually scooped me up off the floor of the ER and did her best to console me, then turned to Steve. She swaddled his body in a nice clean sheet, making sure that every edge was neatly tucked, and she quietly said a prayer as I closed his eyelids with my fingers. I don't know how long passed before I told her I was ready to leave. I had to sign some papers, but there was nothing more to do. Vicki walked me home.

Just a couple of hours after leaving for the hospital, I reentered our apartment. I'd say I was in shock or numbed but, no, I felt everything—*everything*—and it all hurt. In our bedroom, it looked like an earthquake had hit—a lamp knocked over by the EMTs, the bed askew, a broken glass, books—Steve's stacks of beloved sci-fi paperbacks—scattered. The floor was littered with strewn Epinephrine syringes and caps from the defibrillator charges. Vicki and her husband began cleaning up the mess, and called my friends Jane and Paul to come over. I collapsed in the other room. If Steve had died in an earthquake, it would have made more sense to me.

A few days later, I went to see a minister. Neither Steve nor I was religious but I wanted to talk to someone. She did not bring up God or heaven or the afterlife. She was wonderful, more like a doctor

explaining a diagnosis. "Suffering a devastating loss is like suffering a brain injury," she said. She spoke really slowly, which I appreciated. "You walk around like a zombie. You can't think straight. You feel drugged—"

Sometimes you *are* drugged, I thought to myself.

To be safe, I started keeping a notepad inside the medicine cabinet. "Yes, you took an Ambien at 11," I would jot, answering a question I knew I would ask myself when I woke four hours later. Or: "2 X @ 3," meaning two Xanaxes at three A.M.—no wait, maybe it was three in the afternoon? I don't remember now.

In those early days of grief, short on sleep, forgetting to eat, I felt as though I were in a liminal state, not quite alive myself, which made me feel remarkably close to Steve. During that same period, I was continually having amazing encounters with strangers—people who would pop up and offer help, whether at the post office or grocery store, or just say something kind. At the time, I never doubted that they were embodiments of him.

One day I met a man with the name of an angel. He was French. His accent was so thick it sounded fake. We got to talking and I told him what had happened. "You're going to be fine," Emmanuel said right away. "Something bad always leads to something good." He spoke from personal experience. His partner had died six years earlier. But he did not use that word, *died*, as he told me his story. Nor did he say *passed away*, a euphemism I had come to hate. Instead, Emmanuel said, "When my partner disappeared . . ."

I knew this was not a case of poor English, a bungled translation. Still, I had to say something. "You said 'disappeared'—"

He nodded.

"That's exactly how it feels for me, too."

One might think that for someone who has lost a partner or spouse, nights would be hardest, loneliest. For me, this was not the case. I was used to being alone at night, the only one awake. I didn't even have more than the usual trouble sleeping after the first few weeks. I suppose this was partly because Steve and I had never been bedtime cuddlers or spooners, so I was not missing something I'd once had. That said, it was a long time before I was able to take his pillow from his side of the bed. I did not dare. The night after he died, I found that a sliver of light from a streetlamp shone through the blinds just so and cast a single yellowy tendril across his pillow. It was the opposite of a shadow. Which is as clear a definition as I can come up with for the soul.

With morning, the light was gone, and I found the days empty and agonizing. It would take about three years for this feeling to pass—a thousand days, give or take—people who had been through this told me. As it turns out, they were right. What no one said is something I discovered on my own: A thousand days is a thousand nights is a thousand chances to dream about him.

Usually it went like this: Someone digs up his corpse and initiates CPR; he revives in an instant, no problem. I see him walking, talking, a latter-day Lazarus with a flattop and a beautiful body and a crooked grin. Back from death but unchanged by death, with one crucial difference: He does not recognize me. It is I, not he, who has been transformed.

For a while, I tried going on dates—dinner, a movie, that kind of thing. I met a few nice guys. But I could not disguise my lack of interest. There was one man I saw for about a month. His name was, you guessed it, Steve. Even though we had been intimate from the start, we didn't end up spending the night together until the fourth

week. I can still picture the moment when he turned over to go to sleep. His back, illuminated by moonlight, reminded me of the disappeared Steve's.

That was the last time I tried that for a long spell. From then on, I would send them home or, depending on the situation, leave myself. Insomnia was my excuse: I would rather not-sleep in my own bed, I explained. This was not altogether true. I would have liked to stay but could no more imagine falling asleep with someone else than I could imagine falling in love again.

Curiously, though, the reverse sometimes occurred: I would be with a lover, before I made my exit. I'd have him wrapped in my arms as we talked in the aimless, dreamy way that lovers do, like two analysands to an unseen Jung. A pause stretches into a long lull and I hear that unmistakable change in breathing—he has fallen asleep, and improbably, I feel responsible, as though I, of all people, possess the arms of Hypnos. It seems like a small miracle. But here's the rub: As I draw him closer and nuzzle his neck, I cannot help remembering what the Greeks so wisely knew: The god of sleep has an identical twin, Thanatos, the god of death.

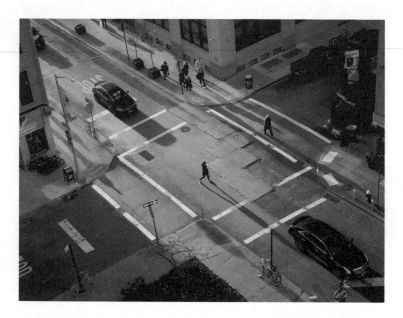

Spring Shadows

BLACK CROW

Five or six months after Steve died, I got involved with a guy named Luke—nothing serious, a casual affair. I met him at the Whole Foods in Pacific Heights, where he worked as a clerk. Luke was two decades younger than me and different from Steve in every conceivable way except one: He looked like him. Tall, built, with a boxer's nose, a prominent jaw, and hands as large and heavy as catcher's mitts. I did not see the resemblance until a few months and many tequila shots later. Actually, a friend—concerned by my infatuation with Luke, a hard-drinking, motorcycle-driving, tattooed Texan with a temper fueled by enormous amounts of steroids—pointed it out to me. By then, I had long since learned that Luke not only had a boyfriend but also another job and went by another name. He was a porn star, a phrase I do not use lightly. He really was a star, his made-up name appearing above the title, in dozens of hard-core films. I would not have known because watching porn had never been my thing, but I did not care any more than I cared about the boyfriend. Truth is, I found it fascinating. The very idea of reinventing oneself— giving oneself a new name, new body, a radically different life—held great appeal. I had begun unconsciously doing so myself.

One night around that time, I cruised a good-looking guy at the gym, as did he cruise me. I saw him in the shower, and then he followed me out of the gym and into the parking lot. "My name's Shane," he said, reaching out to shake my hand.

"I'm Bill," I said, then added, "Billy. You can call me Billy."

It just came out; I didn't even think about it. The name fit in a way that Bill, what I had been called almost my whole life, no longer did. The name is considered a diminutive; I'm aware of that. I was called Billy as a boy. But in middle age, it did not sound that way to me. On the contrary: Billy sounded bigger than me, tougher, invulnerable.

Along with the name came a shaved head, a beard, more muscles, and a tattoo. I had always loved tattoos and, were it not for Steve, who found them repellent for some reason, I would have had at least a sleeveful by then. But something unexpected—unexpected to me, at least—had come with Steve's death. What he thought or would have thought, which used to seem more important than how I viewed myself, had changed entirely. I still felt Steve looking on constantly, but with death he had left behind all judgments. He no longer approved or disapproved. He didn't cast a vote. He wanted for me, I felt, one thing, only one thing: To be happy.

I designed a tattoo that symbolized the end of one life and the beginning of another—Roman numerals for 10/10, the month and day Steve died—and had it inked on a pulse point. It hurt like hell but I loved it. I went over to Luke's afterward to celebrate, tequila and weed serving as my anesthesia. Upon getting home very late that night, I pulled the blinds in every room of my apartment. I had recently taken everything off the walls, all our old pictures and posters, and gotten rid of a bunch of furniture, including the

bed Steve and I had slept in all those years, the bed he'd died in, leaving only a foam-rubber mattress on the floor. It looked like a place where someone was only half-moved in or half-moved out, either scenario being plausible to explain my current state. The hardwood floors gleamed in the moonlight. Cool, foggy air blew through the open windows. I got stoned and put on my iPod. This was a period when I would listen to the same few songs over and over again—Björk's "Hyperballad," "Unravel," and "Undo," Radiohead's "There, There," and Joni Mitchell's "Black Crow," an undanceable song to which I would dance for so long I would sweat. Music, I found, was the most effective balm to my grief.

When I woke the next morning, my sheets were stained with bits of blood and black ink from the tattoo. I stumbled into the kitchen for coffee and had to laugh at what I found left from the night before: At the height of my high, I had written lyrics from "Black Crow" on one of the blank white kitchen walls:

My whole life has been illumination, corruption, and diving
Diving down to pick up on every shiny thing

———————

SOON AFTER, I decided to get away from San Francisco and spend a month in London. I subleased a flat in Camden from a friend for virtually nothing. Before leaving, I gave Luke keys to my apartment—not just duplicate keys, mind you, but Steve's set— which seems bizarre in retrospect. I did so on the pretense that, since Luke and his boyfriend were going through a rough patch, he might

need a place to stay now and then. But the truth was, I liked the idea
of this über-Steve stand-in sleeping in my bed, inhabiting my space.

London wasn't an arbitrary choice. Steve and I had been
there twice to do research for my last book and had fallen in love
with the city. I thought that going back might cheer me. Boy, was
that naïve. No sooner had the plane taken off than tears were
streaming down my face. I might have turned around and left
London in days had it not been for a single item I'd brought with me:
a camera.

Impulsively, I had bought a pocket-sized digital Canon the night
before leaving San Francisco. If I had thought it through, I would
have talked myself out of it; I was traveling by myself, after all, and
wouldn't be taking snapshots at tourist sites of or with anyone. But
as I quickly realized, the camera itself was my travel companion. It
gave me a reason to leave the flat every day and search for pictures in
parts of London I had never seen before.

The photos were not for anyone but myself, which in itself was
new. All my writing over the past sixteen years had been, to a great
extent, first and foremost for Steve (all three of my books were identi-
cally dedicated to him). Our life together had been challenging in
many ways: He'd had HIV/AIDS; I was HIV-negative. We went
through a lot together as he survived bouts of different AIDS-related
illnesses and symptoms—chronic diarrhea, pneumonia, wasting
syndrome, night sweats—as well as, bizarrely, a benign brain tumor
that caused a condition called acromegaly (for which he had to have
neurosurgery). When the protease inhibitor drugs arrived in the late
1990s, they saved his life, and he enjoyed several years of good, stable
health. Which was but one reason his sudden death from a heart
attack was so shocking; it was most likely triggered by an episode of

ventricular fibrillation and had nothing directly to do with HIV, an autopsy confirmed.

Although the pictures I took in London were not for Steve, they evoked him nonetheless. He'd loved everything about the London Tube system, for instance, and so I spent hours underground, taking trains, hanging out in stations, riding the steeply raked escalators, looking for photos.

Couples captivated me—on the Tube, on park benches, arm in arm on the street. Couples so in love you could see it in their faces. But I couldn't take pictures of their faces, and not because I was too shy to ask for a shot. Their smiles were heartbreaking. Instead, I took pictures of their hands, laced together as if in prayer, or their feet—the erotic dance that is a prelude to a kiss.

Steve's birthday fell while I was in London. He would have been forty-four. I decided to spend the day revisiting sights he had especially loved, such as the Rosetta Stone at the British Museum and a hole-in-the-wall comic book shop in Camden. But if I had been hoping somehow to pick up his scent along the way, all I found was that it was gone.

I ended the day with a long, zigzagging walk across London's bridges. I'd brought with me several small personal items that I had not been able to—but wanted to—part with. For instance, his contact lenses, which had just been sitting in the medicine cabinet at home in San Francisco. To me, his contacts were as much a part of his body, his life, as his eyes. Without them, he could hardly see. I tossed them into the Thames and thanked him for showing me a million things. Each subsequent bridge became an occasion for a ceremonial purging and a fresh round of tears. By the time I reached London Bridge, where I scattered the last of his cremated ashes, the only significant

thing remaining of Steve's that I had not thrown in was myself. Not that I didn't consider it.

GOING THROUGH grief is not a uniquely human experience. The fact that fellow primates—chimps, orangutans, lemurs—manifest grief-like behavior is beyond dispute, scientists agree. Upon the death of an infant, for instance, a rhesus monkey mother will carry her dead baby in her mouth for days and days—as if in a fog of sorrow, literally unable to let go—until only skin and bones remain.

For wild geese such as greylag, which, like swans, tend to bond for life with a single partner, the loss or disappearance of a mate triggers equally heartrending behavior. First, the bird anxiously attempts to find the lost one. Scarcely sleeping or eating, it moves about restlessly day and night, flying great distances and visiting all the places where the missing might be found.

In its frantic searching, the searcher often gets lost and can't find its way back to its colony. It may succumb to the elements. But if the bird does return, it is clearly changed; it becomes shy and fearful, fleeing even the youngest and weakest geese. The bird develops a tendency to panic and hence becomes accident-prone. No matter the age, its rank in the colony sinks to the lowest level. What's more, the bird undergoes a physical transformation.

"Just as in the human face, it is in the neighborhood of the eyes that in geese bears the permanent marks of deep grief," notes Nobel Prize–winning ethologist Konrad Lorenz. "The lowering of the tonus in the sympathicus causes the eye to sink back deeply in its socket and, at the same time, decreases the tension of the outer facial

muscles supporting the eye region from below. Both factors contribute to the formation of a fold of loose skin below the eye which as early as in the ancient Greek mask of tragedy had become the conventionalized expression of grief."

In one respect, however, the greylag, like the grief-stricken chimp or dog or crow, differs dramatically from the bereft human; it does not weep. An animal's eyes produce tears for lubrication, but don't shed tears of sorrow. At least, so far as we know. I sometimes wonder if this simply has not been, nor ever will be, observed by humans. Instead of searching for their lost mates, perhaps those lonely, broken birds, not unlike myself in London, are purposely flying into the coldest headwinds and just letting the tears fall.

Subway Love

O AND I

He wrote me a letter. That's how we met. He had read *The Anatomist* in proof, and enjoyed it. ("I meant to provide a blurb," but "got distracted and forgot"—an admission I found charming.) This was when I was still in San Francisco—early 2008. This was when people still wrote letters regularly (which was not that long ago), and when one got a letter sat down and wrote a letter back.

"Dear Mr. Hayes—"

"—Dear Dr. Sacks . . ."

Thus, a correspondence between O and me began.

A month later, I happened to be in New York and, at Oliver's invitation, paid a visit. We had lunch at a café across the street from his office: mussels, fries, and several rounds of dark Belgian beer. We lingered at the table, talking, well into the afternoon. We found we had something other than writing in common: He, too, was a lifelong insomniac—indeed, from a family of insomniacs. ("It was understood at an early age that one could not sleep without sedation," he told me wryly.)

I had not known—had never considered, as far as I recall—whether he was hetero- or homosexual, single or in a relationship. By

the end of our lunch, I hadn't come to any firm conclusions on either matter, as he was both very shy and quite formal—qualities I do not possess. But I did know that I was intrigued and attracted. How could one not be? He was brilliant, sweet, modest, handsome, and prone to sudden, ebullient outbursts of boyish enthusiasm. I remember how O got quite carried away talking about nineteenth-century medical literature, "its novelistic qualities"—an enthusiasm I shared.

We stayed in touch. I sent him photographs I had taken in Central Park of bare tree limbs. I thought they looked like vascular capillaries. With his neurologist's eye, he felt they looked like neurons.

"I am reminded of how Nabokov compared winter trees to the nervous systems of giants," he wrote back.

I was sort of smitten, I had to admit.

Even so, that was that—for then. There was an entire country between us, not to mention thirty years' age difference. My decision to move to New York more than a year later really had nothing to do with Oliver, and I certainly did not have a relationship in mind. I had simply reached a point in my life where I had to get away from San Francisco—and all the memories it held—and start fresh. But once I moved, O and I started spending time together and quickly got better and better acquainted.

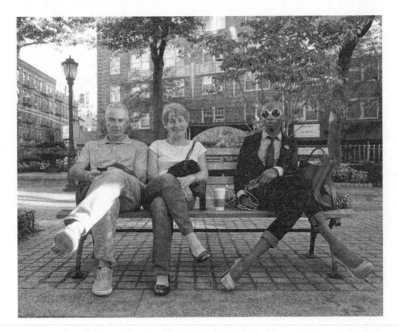

The West Village

ON BECOMING A
NEW YORKER

I had gotten here just like millions of others before me and since: on a one-way ticket and with only vague notions of how I'd make it. I had no savings, and all my belongings were packed into a few suitcases. I'd landed at Kennedy Airport, bought my first MetroCard, and put ten dollars on it. Had I known about unlimited-ride passes, no doubt I would have splurged on one, but even so, *unlimited* was how I felt: freed from what was, unworried about what came next.

From Kennedy, I took an A train headed for Far Rockaway. That was the wrong direction for getting to Manhattan, as New Yorkers will recognize and as I eventually figured out. But taking wrong trains, encountering unexpected delays, and suffering occasional mechanical breakdowns are inevitable to any journey really worth taking. One learns to get oneself turned around and headed the right way.

On my first night in New York, I stayed with a friend of a friend on the Upper East Side. The next morning, I went out and bought a mattress and arranged for it to be delivered that day to the tiny

apartment I'd already found in the West Village. I remember sitting on the floor in my empty bedroom waiting for the truck to come when I got a call on my cell phone from a number I didn't recognize. It was the sister of my downstairs neighbor from my apartment building back in San Francisco; she wanted to notify me that her sister had died.

Jeffie, a tough old bird with a young boy's name, had had lung cancer. I'd spent a good bit of time with her before I left, helping her out now and then, or just talking. She had bright blue eyes. She was scared to die. She was happy that I was moving to New York City. She did not want me to grow old and alone in that building, as she had.

When I went down to say a last goodbye to Jeffie, she insisted I take something of hers with me. Anything I wanted, it could be. I had always loved her dusty old table lamp—a mid-century piece actually bought at mid-century. "It's yours," she said, and so it is, sitting now on my desk as I write this. The lamp's shade casts the softest, warm amber glow, as if suffused with her; indeed, it is tobacco-stained from her years and years of cigarette smoking.

After getting the news about Jeffie, I dashed down the six flights in my building and went straight into the German restaurant across the street. I ordered a beer and stood by the window, so I could watch for the truck delivery. I got to talking to a man standing there. Larry was his name; a big guy in a well-worn gray suit. He was waiting for his wife. I told him I'd just moved here, and without another word he gestured to the bartender.

"Patrón," he said.

We clinked shot glasses.

"Welcome," Larry said, "welcome to New York," and the tequila

tasted as clean and bright as metal—like an element with a name I couldn't pronounce.

I hadn't finished half my beer when the truck pulled up.

"There's my bed."

"Now you've officially got a home. Tab's on me, go for it."

He gave me his card and told me if I ever needed help, help of any kind, give a call. After all this time, almost ten years later, I still have it: Lawrence H. Stein, Attorney at Law.

I HAD visited New York many times over the years but living here, as I soon discovered, is a whole different ballgame. On the other hand, one doesn't become a New Yorker by virtue of having a New York address. For me, the moment came the first time I left the city. I flew back to Seattle for Christmas to see family. No sooner had the plane lifted off than I felt a pang of regret. *To be a New Yorker is to be away from the city and feel like you are missing something*, I wrote on a cocktail napkin. By this I didn't mean missing the Rockettes at Radio City, New Year's Eve in Times Square, or some amazing exhibition at the Met. In New York, there is always something amazing happening somewhere that one ends up hearing about only later.

What I meant instead was missing the evanescent, the eavesdropped, the unexpected: a snowfall that blankets the city and turns it into a peaceful new world. Or, in summer, the sight of the first fireflies in the park at twilight. The clop-clop of horses' hooves on cobblestones in the West Village, mounted police patrolling late at night, or a lovers' quarrel within earshot of all passersby. Of course,

what is music to my ears may be intolerable to another's. Life here is a John Cage score, dissonance made eloquent.

It's in the subway where I find the essence of this. Every car on every train on every line holds a surprise, a random sampling of humanity brought together in a confined space for a minute or two—a living Rubik's Cube. You never know whom you might meet, or who might be sitting next to whom. I prefer standing to sitting and would never doze or read while I ride. To do so would be to miss some astonishing sights—for instance, when two trains depart simultaneously and, like racehorses just out of the gate, run neck and neck for a time.

If it's late at night, I try to get into the first car and stand up front, so I have a clear view through the windshield. As the subway barrels ahead, star-like lights flickering on either side, I feel as though I am on a rocket hurtling through deep time, with no idea where we will land, or how, or when.

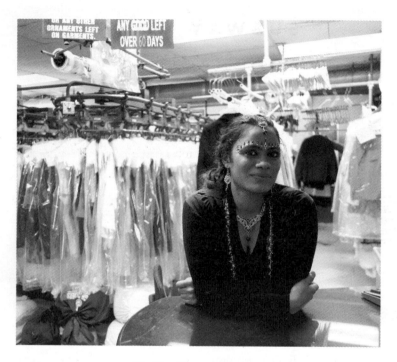

The Dry Cleaner's Daughter

SUBWAY LIFER

During my first year in New York, I took the A/C line to work each day. I had a full-time job raising money for a global nonprofit dedicated to developing an AIDS vaccine. The West Fourth Street station was five minutes from my apartment. My favorite time was early morning. The station wasn't crowded yet, riders weren't rushed. People did not talk but read or listened to iPods. The smokers hacked their smokers' coughs. Water drops—rusty tears in winter, I'd imagine, beads of sweat in summer—leaked from the steel I-beams overhead. The air was soft, as if unfinished dreams still emanated from everyone's skin.

Waiting, however, can be a delicate business. Patience can turn to impatience in a flash and prompt a stance I've come to call the lean-and-look. This involves standing on the yellow strip at the edge of the train platform, one foot firmly planted, the other extended back, and leaning out far enough (but not too far) to see if a subway is coming. It's one step away from being either suicide or a minimalist dance move. One after the other, people would come forward and do it, myself included, as if collectively we could coax a train out of the tunnel.

Sometimes it actually worked and, on rare occasions, brought forth not one train but two: an A on one side of the platform, a C on the other. At such moments one realizes that even the smallest choices *matter*. Both trains went to my stop at Fulton, but the A was an express and the C, a local, was poky. Each attracted different riders, different personalities. *Which am I this morning,* I would think, *an A or a C?* And what might happen in the extra minutes gained by the express? Will I bump into my next love as I exit, or trip and break my leg?

On weekends, I tended to take the red line; a 1 stop was just down the street. Other than Oliver, I didn't know many people here, which suited me fine. My primary relationship was with the city—like an Mbuti pygmy's is with the forest. We got to know each other via long subway rides—through Harlem and Washington Heights, Brooklyn and the Upper West Side. I would always carry my camera with me, and I took to approaching people on the street who caught my eye— strangers—whether because they looked interesting or attractive or unusual or, perhaps, utterly ordinary. "Can I take your picture?" I'd simply say.

After a day of exploring the city, one night I ended up in Midtown at Lincoln Center. I stood for a long time in front of the Metropolitan Opera House, watching the luminous dance of the fountain at its entrance. I got a ticket, last-minute, to an opera just about to begin. The lights dimmed and the crystal chandeliers made their silent retreat into the ceiling. I found myself shedding a few tears as the overture started. Did I wish there were someone with me? Perhaps. So I wasn't shy about sharing my joy with others at intermission.

For some reason, there were no subway trains at Columbus Circle that night. I didn't have money for a taxi, so I started walking. Eventually I stopped at the Fiftieth Street station. It was empty save

for a blind man tap-tap-tapping a jagged line on the platform. I watched him for a while, then, worried that he might fall to the tracks, steered him toward a back wall. We introduced ourselves; his name was Harold. It was past midnight and we were both going home—I to Christopher Street, Harold to 155th.

Now, I still didn't know a lot about subway lines at the time but felt pretty sure that if Harold wanted 155th, he was headed the wrong way, and I gently told him so. He responded with a seeming non sequitur: "Sometimes, Billy, you have to go down to go up." Just then a train came and we rode together to Forty-Second Street, where Harold got off and disappeared into a crowd. It was only then that I understood he hadn't been dispensing sage advice about weathering the ups and downs of life in New York. The uptown station at Fiftieth Street had merely been closed.

I am told by longtime New Yorkers that the subway used to be awful—garbage-strewn, graffiti-covered, suffocating in the summer, dangerous late at night all year round. And of course I know plenty of people who despise taking it today, even though the cars are remarkably safe, clean, and cool. I suggest they ride with me. I cannot take a subway without marveling at the lottery logic that brings together a random sampling of humanity for one minute or two, testing us for kindness and compatibility. Is that not what civility is?

The other day, I was on a local 6 going uptown and seated next to a young woman with a baby in a stroller. At each stop, a man (always a man) would enter the car and end up standing right above us. I had my iPod on and was just watching. Inevitably, each man would make goofy faces and smile at the baby, and the baby would smile and make faces back. At each stop, the standing man would be replaced by a new one, straight out of central casting: First, an older Latin guy.

Then he gets off and a young black man appears. Then a white man in a suit. Then a construction worker with a hard hat. Tough guys. New York guys. All devoted to one important task: making a baby smile.

I have other subway stories to tell. And I could list lots more reasons why I like riding the 1, 2, 3, C, F, D, 4, 5, or L. But if pressed, I'd have to say that what I love most about the subways of New York is what they do not do. One may spend a lifetime looking back— whether regretfully or wistfully, with shame or fondness or sorrow— and thinking how, given the chance, you might have done things differently. But when you enter a subway car and the doors close, you have no choice but to give yourself over to where it is headed. The subway only goes one way: forward.

NOTES FROM A JOURNAL

5-9-09:

O says I must keep a journal.

And so I must.

I make notes on scraps of paper, the backs of envelopes, cocktail napkins. Sometimes dated, sometimes not.

———————————

5-12-09:

I brought over a bottle of wine and we went up to O's rooftop.

My one-month anniversary in NYC:

"Shall I get glasses?" asked O, flustered.

"No, no need."

We took turns swigging from the bottle.

———————————

5-31-09:

My friend Miguel visits my place. There's nowhere to sit except the floor. "This apartment should not be legal," he says. "There must be some code somewhere that's being broken."

———————————

6-2-09:

To remember:

How I wake at 5:30 and watch the trees outside my window—the branches look like they are floating on wind drafts.

How the leaves flutter like giraffe's lashes.

How I take a shower with the sun, a bird and a squirrel watching me.

How as the sun rose, the Chrysler cast a shadow on the MetLife building.

6-17-09:

"Are you seeing anyone?" someone asks.

"Only New York," I answer.

This is not 100 percent true.

O isn't comfortable with anyone knowing about us and gets palpably nervous if we are out together and see someone he knows.

At the Bodega

THE SUMMER
MICHAEL JACKSON DIED

It was nighttime, June 25, 2009, and I was standing at a streetlight on Seventh and Greenwich Avenue when I heard the news. Someone said it out loud, like a town crier, as he crossed against the light: "MICHAEL'S DEAD! MICHAEL'S DEAD! MICHAEL'S DEAD!" His death struck me as a rebuke to tabloid journalism, tabloid culture. Everything written about him, everything rumored, all the insinuations and allegations that had hounded him, driven him into isolation, his freakishness—none of it meant anything anymore, I felt sure. The only thing that would matter from now on was Michael's music, which one heard everywhere in New York—blaring from car radios, playing in bars, boom boxes on stoops, and people dancing, literally dancing, on the streets and sidewalks and subway platforms. It sounded so innocent, joyful, romantic almost. At least, that's how it seemed for a week or so. And then details started to emerge about his death—his OD'ing on anesthesia, the unseemly doctor, the lifetime of insomnia and sleeping pills—and soon Michael Jackson's death was less Sylvia Plath, more Anna

Nicole Smith. Very quickly, his music took on that tawdry quality, too. It all sounded wrong, tarnished or fraudulent somehow. I couldn't hear "Rock With You" without picturing an insomniac Michael being put under with propofol.

I remember O had no idea who Michael Jackson was. "What is Michael Jackson?" he asked me the day after the news—not who but *what*—which seemed both a very odd and a very apt way of putting it, given how much the brilliant singer had transmuted from a human into an alien being. O often said he had no knowledge of popular culture after 1955, and this was not an exaggeration. He did not know popular music, rarely watched anything on TV but the news, did not enjoy contemporary fiction, and had zero interest in celebrities or fame (including his own). He didn't possess a computer, had never used e-mail or texted; he wrote with a fountain pen. This wasn't pretentiousness; he wasn't proud of it; indeed, this feeling of "not being with it" contributed to his extreme shyness. But there was no denying that his tastes, his habits, his ways—all were irreversibly, fixedly, not of our time.

"Do I *seem* like I am from another century?" he would sometimes ask me, almost poignantly. "Do I seem like I am from another age?"

"You do, yes, you do."

For me, this was part of the fascination with, part of my attraction to, him. I was seeing a few other men during my first summer in New York, but dates with O were completely different. We didn't go to movies or to MoMA or to new restaurants or Broadway shows. We took long walks in the botanical garden in the Bronx, where he could expatiate on every species of fern. We visited the Museum of Natural History—not for the dinosaurs or special exhibitions but to spend time in the often-empty, chapel-like room of gems, minerals, and,

especially, the elements—O knew the stories behind the discoveries of every single one. At night, we might walk from the West Village to the East, O talking excitedly nonstop, to have a beer and burger at McSorley's Old Ale House.

I learned that not only had he never been in a relationship, he had also never come out publicly as a gay man. But in a way, he'd had no reason to do so—he hadn't had sex in three-and-a-half decades, he told me. At first, I did not believe him; such a monk-like existence—devoted solely to work, reading, writing, thinking—seemed at once awe-inspiring and inconceivable. He was without a doubt the most unusual person I had ever known, and before long I found myself not just falling in love with O; it was something more, something I had never experienced before. I adored him.

Oliver and the Crabapple Trees

NOTES FROM A JOURNAL

7-09-09:

> O's 76th birthday:

> After I kiss him for a long time, exploring his mouth and lips with my tongue, he has a look of utter surprise on his face, eyes still closed: "Is that what kissing is, or is that something you've invented?"

> I laugh, disarmed. I tell him it's patented—he's sworn to secrecy.

> O smiles.

> "And if I hold you closely enough, I can hear your brain," I tell him.

8-18-09:

> We talk about a scene in *Roman Elegies* in which Goethe taps out hexameters on his sleeping lover's back:

> "*Fingertips counting in time with the sweet rhythmic breath of her slumber*," O recites from memory.

> "Or *his* slumber," I add.

9-29-09:

Sometimes people recognize Oliver. Tonight, a young man approached our table and introduced himself. He was very flirtatious, which O enjoyed but did not reciprocate. "I already have one delectable addition to my life," he said later. "That should be enough."

———————

9-30-09:

Funny:

I like to get kind of verbal in bed sometimes, but I am finding this does not work well when you're having sex with someone who's practically deaf:

"What was that? Were you saying something?" O will ask in the heat of things with great sincerity.

"Oliver! Don't make me repeat it!"

At which point, we both dissolve in laughter.

"Deaf Sex," we affectionately call this.

———————

10-24-09:

Taking a C train from Seventy-Second to Fourteenth: I dash
into the crowded car, reach for a pole to steady myself. The
pole is still warm with heat from other riders' hands.

"Did it hurt?" I hear.

I turn in the direction of the voice. Seated beneath me, a
young Latina—maybe nineteen or twenty—meets my eyes.
"Did that hurt?" she asks pointing to my arm. "Your tattoo?"

I smile. "Yeah, it did actually. The skin there is really thin—
lots of nerve endings. But it was worth it."

She nods.

"What do you want to get?" I ask her.

"A fairy—a little fairy—and then the Egyptian hieroglyph for
destiny."

She is wearing a copper-colored wig, cut into a blunt bob with
severe bangs. She looks a like an Egyptian princess. She is the
Cleopatra of the C train.

"That sounds wonderful," I tell her. "Go for it."

Cleopatra smiles and settles back into her seat.

———————————

10-31-09:

O: "I don't so much fear death as I do wasting life."

Undated Note—October 2009:

Visited O in the hospital—a total knee replacement (alas, all those years of super-heavy weightlifting). At first, he looked mortified because a friend, who doesn't know about us, was visiting him. But then, I could tell, he was happy I came.

———————

11-11-09:

Knee surgery has exacerbated other problems—sciatica and disc pain so severe O cannot sit to write. He might have to have back surgery. I construct a standing desk on the kitchen counter made from stacks of books and a nice flat piece of wood I found in the basement. He works nonstop through the night on his new book, *The Mind's Eye.*

"Writing is more important than pain," he says.

———————

Undated Notes—December 2009:

My head on O's chest, he caresses my biceps, very, very softly. I think the Dilaudid has kicked in.

"You like those?" I ask.

"Oh yes—they're like . . . beautiful tumors—"

I chuckle—how flattering.

"—voluptuous tumescences . . . !"

———————

I: "Do you need anything?"

O: "Could you pull off my socks?"

I smile, and do so, kiss him on the forehead, and say good night.

"I feel beautifully comfortable with you," O says.

11-21-09:

Note to self, on the back of a Verizon envelope:

"Sometimes it will be difficult and you'll question why you ever moved here. But New York will always answer you."

Yes, remember that: New York will always answer you.

12-22-09:

On my way to the airport to visit family for the holidays, I stopped by O's office to say goodbye. I found myself confessing something that has been gradually formulating in my mind for many weeks now, but never expressed: "I am in love with you, Oliver." He fought back tears. I kissed his head, held him, told him it's going to be okay, I'd be back from Seattle soon. He nodded. We walked out to the main room, where his two assistants, Kate and Hailey, work. "Watch over this guy," I said. Then O and I (no longer having privacy) shook hands.

12-26-09:

O, on the phone from NY, stutters to speak: "I know that I
put up all kinds of restrictions. Barriers. And was reluctant to
go places with you in public. I now want to say that I love you,
too, and I would be happy to go anywhere with you."

I am smiling broadly on the other side of the country.

"And I, with you, young man," I tell him.

Young Love in the Park

A FISHERMAN ON

THE SUBWAY

I met a fisherman on the 1 train one night.

It would have been hard to miss him even in a packed subway car. His two large fishing rods, like a pair of periscopes, towered a good head above anyone else. He had gotten on one stop after me. Gripping his poles with one hand, a train pole with the other, he studied the subway map over my shoulder. He was tall, maybe six-two, in his mid-twenties, and could have been part Dominican, part Vietnamese—island countries.

I watched his face as his scrunched-up eyes traced his route on the map and he got his bearings. Satisfied, he looked around then settled into the empty seat next to me. He corralled his poles between his knees.

You can't be sitting next to a fisherman on a subway and not say something.

"Catch any?"

"Not today." This did not appear to trouble him.

I was coming from work. The idea of coming from fishing instead

of your job seemed pretty sweet. "Where would one go—where would I go if I wanted to fish?"

"Staten Island. Great fishing there—striped bass. But today I went to Battery Park—off the pier. Didn't have much time. Just an hour."

"Not even a nibble?"

"Oh yeah, lots, but no catches. They take a bite, feel something, feel the hook, spit it out. They're smart, those fish. You're sadly mistaken if you think you're in control when you go fishing."

He sounded like he knew what he was talking about.

I said I'd take his word for it.

"You gotta be patient," he elaborated. "You can't go out there for just an hour and expect to catch. They feel you out. I went today just to be out there—"

"—with the fish?"

He nodded. "And on the water."

You can get so caught up in your life in New York that you forget: We live on an island, I thought to myself—an *island*. "That's cool," I murmured.

"Night's the best time—if it's clear, the stars are out, fish are running—"

I could almost picture it. I saw the Empire State Building in the background.

"Once I got a shark," he said, more animated. "A basking shark— ugly thing. This was during the day. Took hundred-pound line and over an hour to pull him in."

"Sharks in New York—now somehow that does not surprise me."

He laughed.

The fisherman looked at his wristwatch and said he was just

going to make it in time—just barely. He had to be at work in the Bronx at six.

I noticed that his watch already said six and mentioned this.

"Yeah, I keep it fifteen minutes fast—I'm always running late. I can't stand to stop fishing."

"Man, that's love." I stood up. "I wish you no subway delays—and no more sharks." I said so long and got off at my stop.

He kept riding. He was going to make it just in time.

At Blue Mountain Center

NOTES FROM A JOURNAL

1-11-10:

> O: "Every day, a word surprises me."

1-18-10:

> O: "It's really a question of mutuality, isn't it?"
>
> I: "Love? Are you talking about love?"
>
> O: "Yes."

2-1-10:

> A languid Sunday, afternoon turning into evening, evening into night, night to morning.
>
> "I just want to enjoy your nextness and nearness," O says.
>
> He puts his ear to my chest and listens to my heart and counts the beats.
>
> "Sixty-two," he says with a satisfied smile, and I can't imagine anything more intimate.

2-7-10:

> O tells me about a white-winged butterfly, made dirty by city soot early in the industrial age in England, which evolved quickly from white to soot-colored. And about a city bird

(pigeon?) whose song rose in volume to be heard over the honking of cars, the noise of construction, traffic.

"There are rare instances in nature of accelerated evolution."

I can't help thinking of how much O himself has changed over the past year.

"I've noticed that," I tell him.

6-9-10:

We are on the roof of O's building; 7 P.M.; the breeze is wonderfully warm; the sun is setting; and the clouds, against some stiff competition from the Manhattan skyline, are far more striking than anything in sight. But O is not able to look at them because he had surgery to remove a blood clot in his right eye (which he hopes will restore some of the sight lost when he was treated for melanoma on his optic nerve). For the next few days, he has to keep his head tilted down at all times to prevent further clotting or fluid accumulation.

"Tell me what they look like," O says. "Describe the clouds."

I pull him in close, so his face is buried in my chest, and I look to the sky. "Well"—I'm not sure where to begin—"they are large. *Very* large."

"Yes?"

"And what's especially remarkable is—yes, I'm not just seeing things—they are not moving, not moving at all. Which is surprising, because the wind is strong. But it's as if they are

holding their pose, so I can study them, so I can describe them to you."

"Oh, lovely," O murmurs.

"What I'm noticing, as never before, is not how white they are but how gray—a wonderful bluish-gray—pewter-colored."

"Like osmium?" O asks, hopeful, delighted.

I chuckle. "Yes, just like osmium—clouds of osmium."

"Oh, I have to look," O says and steals a hungry glance at the sky.

We had come to the roof, as is our custom, to have some wine. Normally, we take swigs straight from the bottle. But O, to prevent tilting his head back, has brought a straw. He takes a long sip from the bottle then passes it to me. It's funny—drinking good cabernet through a straw—and even funnier when I finish my sip and the straw bobs back into the bottle—irretrievably.

I go back downstairs for another straw.

Returning to the roof, I find O hugging the rooftop railing.

"What do you see?"

"Oh, I've just been looking at the colors, and shapes, and shadows," he says.

"Nice—show me."

"There"—he points down to a pink-colored building. We watch the colors and shadows for a long while without talking. Then, O says what I have been thinking: "This is the perfect thing to do when you've had eye surgery and can only look down."

We watch people walking down sidewalks, across streets, and we anatomize the different ways people walk: "There is striding. And scurrying. And rushing. And loafing. And ambulating . . ."

That last word sidetracks him, and he goes on: "Ambulating. Ambulate. Ambulation . . . I wonder if that comes from . . . ? Let's go look it up in the *OED*."

7-10-10:

O, in the car, on a drive back from the Botanical Garden— reclining all the way back in his seat (because of sciatica); two pairs of sunglasses on (because of his eye)—suddenly speaks, startling me (I thought he'd been sleeping):

"I've suddenly realized what you mean to me: You create the need which you fill, the hunger you sate. Like Jesus. And Kierkegaard. And smoked trout . . ."

I: "That's the most romantic thing anyone has ever said to me—I think."

O chuckles, then adds: "It's a kind of teaching, in a strange way . . ."

Later: I thought he was gazing at me lovingly as I drove, but then realized, no:

"I'm watching the odometer and thinking of the elements," says O.

8-17-10:

I stop by O's to bring him an ice cream bar. I mention I saw fireflies in Abingdon Square Park—fireflies!

O: "Did you keep your mouth shut?"

I: "What do you mean keep my mouth shut?"

O: "They say three will kill you—*luciferase*, dangerous stuff."

I am laughing, but he is not. I really cannot tell if he is serious.

O: "I don't want you to die of fireflies . . . a luminous death!"

———————

12-27-10:

Palace Hotel, San Francisco—Over Christmas:

In bed, lights out:

O: "Oh, oh, oh . . .!"

I: "What was that for?"

O: "I found your fifth rib."

In the middle of the night: "Wouldn't it be nice if we could dream together?" O whispers.

———————

1-1-11:

To Do:

- Rent check, etc.

- New phone?

- Apartment!

- Call Mom

- Buy/Start journal

––––––––––––

1-4-11:

On the word *list*:

I: "What do you list toward, Oliver?"

O: "Other than libidinal listings?"

I: "Those go without saying."

O: "I want a flow of good thoughts and words as long as I'm alive . . . and you? What do you list toward?"

Man Waiting to Get Into a Fashion Show

A POEM WRITTEN ON
THE STARS

I went out for a walk at about six thirty. Someone said it was supposed to rain but the skies looked clear to me. I headed up Eighth Avenue, crossed over at Twenty-Third Street, and at Tenth Avenue saw a stairwell going up and took it. I was on the High Line. That much I'd expected. What I had not anticipated was how crowded it would be, like being stuck on a moving sidewalk at an airport. But the night was too nice to begrudge anyone anything, particularly a chance to experience beauty.

So I imagined I was a tourist, too, headed for a distant gate to board a plane to a place I've never been.

Somewhere along the way, I lost my hat. I didn't realize this until I had exited the park at Thirtieth Street, by which point I couldn't imagine going back up to retrace my steps. I chose to take the lowlife route home, in the shadow of the High Line, instead.

It's a different world down there. I stood at the mouth of a car wash, circa 1970, empty but operating. I came to a gas station where fourteen taxis were lined up for a single pump. I almost hopped in

one but kept walking. I saw a pay phone up ahead—a pay phone!—
and had to take a look. I flashed on how you had to plug them with
quarters when making a long-distance call—the sound of the coins
dropping, the magic of voices connecting, the disconsolate feeling
when your coins ran out.

One man was using the phone, another leaning against the booth
waiting in line. The leaning man was dark-skinned and looked
striking in his dark clothes, as if dressed for cold weather. He was
holding a bouquet of white roses. He looked as if he lived on the streets.

I smiled at him and tipped my missing hat. "Gorgeous night," I
said, and I felt it was true, though the streets here were deserted and
dirty; part of the gorgeousness in that moment was he and the old
phone booth. He smiled back.

At the corner, I felt a presence and turned around. The man with
roses was walking toward me very fast. The rose heads bobbed up
and down against his chest, and I thought of a dozen bareheaded
babies.

"I know you," I heard him saying. "We've met."

I did not rule this out. I had had many memorable encounters
with strangers in my years in New York. The man stopped in front
of me and stared into my eyes as if trying to read my mind. Then his
eyes brightened. "Did I write a poem for you?" he said.

I stared back, searching my memory. A curtain lifted: Winter,
2009. Two in the morning. A snowstorm. I get out of a cab at Seventh
and Christopher, and see a homeless-looking man on the corner. I
give him the five bucks left from my cab fare. He thanks me but says
he never takes something for nothing. All he can give me is a poem
in return. He gives me a list of options.

"A love poem, of course," I request. And so he stands there, in the

whirling snow, and recites by heart a poem about love—and, being about love, heartbreak. The words go from his mouth to my ears and are carried off by the wind. Two-and-a-half years later, on a different corner but under the same sky, we met again.

"Billy, I'm going to write another poem for you," he said. His name, he reminded me, was Wolf Song. He wanted to write it down for me this time. Neither of us had anything to write with. "Will you buy me a pen?" the poet asked.

There was a convenience store behind us. I bought Wolf Song a black ballpoint pen for a dollar. He got a beer from the fridge; I paid for that, too.

We left and started walking. "Come on, I'm taking you to my archive," Wolf Song said. "You'll see; it's covered with poems." He had the pen behind his ear and his beer in a paper bag.

I got a little nervous. The sun was setting. We were heading down a nearly empty street. From above us on the High Line came the buzz of the crowd; if I were to yell, no one would hear me.

"We need some paper, Billy," he said.

There was a scrap of newspaper on the sidewalk, torn from the *Times*. He picked it up. Something caught my eye: "Look, there's a map of the sky." I recognized the Sunday "Sky Watch" column—a chart of the constellations.

Wolf Song looked stunned. He said he'd been thinking about a poem about the sky all day long. "It was meant to be, then," I said. "Will you write it on the stars for me?"

He led me to his archive: a doorway, just a little enclosure. There were no poems posted on the walls. But to him there were. This was his retreat for poetry-making. I could almost feel his words encircling us.

Then he walked toward a car parked on the street. He put the roses and his can of beer on the hood—his desk. He put the newspaper down, and then hesitated, pen in hand, as if suddenly self-conscious. "You write it," he said. "I don't have good handwriting."

I assured him that it would be fine.

"OK, Billy, this is only for you," he said, and slowly, painstakingly, carefully forming each letter, he wrote his poem over the map of constellations. When he finished, he read it aloud, a koan to the heavens.

Sky why

So Much

Pain is

The Rain

Drops eyes

To Your

Story

We both looked at the words of the poem on the scrap of paper on the empty street under the High Line and the darkening sky. Something passed between us. Both of us had tears in our eyes.

We shook hands and thanked each other. He gave me my poem

and three roses, leaving nine for himself to give to other New Yorkers he would meet that night under the starry sky.

"We will see each other again," I told him. "I know it."

I turned and began walking. It was only then that I read the text accompanying the sky map in the newspaper:

This week the planet Venus will pass in front of the sun, becoming evident as a small black circle slowly moving across the solar disk. Such an occurrence is called a transit of Venus, one of the rarest of astronomical events.

It went on to say that only six times in recorded history have humans witnessed the transit of Venus in front of the sun, a chance meeting of two celestial bodies. After this one coming up on Tuesday, the next transit wouldn't be for 105 years.

When I got to the corner, I looked back to wave at the poet, but he was gone.

NOTES FROM A JOURNAL

1-8-11:

O: "I don't regret the things I've done but those I haven't done. In that way, I'm like a criminal . . ."

———————————

2-13-11:

O: "Can one enjoy two pleasures at the same time?"

I: "Like what? Give me an example."

O: "The taste of broccoli and the feeling of your leathered thigh."

I: "Broccoli? That's your example?"

O: "It's co-perception, isn't it? They get fused in a certain way but don't get de-identified . . ."

———————————

3-17-11:

O tripped on a rug and fell in the office, fractured his hip. In hospital.

Coming out of anesthesia this morning and seeing me, O said, "You look very pretty . . . If it were under less public conditions, I would kiss you."

I kissed him anyway.

———————————

6-7-11:

In Seattle, I call O from the hospital where my mother is clearly near death. He urges me to go out with friends and have some laughs. "When my mother died," he tells me, "my oldest friend called up straightaway and told me three scandalously obscene jokes in a row. I laughed uproariously, and then the tears came."

I follow his advice.

6-19-11:

One morning O tells me he had dreamt the word *nephological* (the study of clouds); another day, it was *triboluminescence*.

I: "Such a lovely word—why triboluminescence?"

O: "I like lightbulbs."

This didn't seem to answer my question but I liked it anyway.

He asked me to bring the volume from the *OED*—and a magnifying glass.

O: "Well, that's interesting! Tribology . . . Tribometer . . . Let's see . . ." He keeps searching. "Here we are! 'Triboluminescence: the quality of emitting light under tremendous friction or violent pressure—1879.'"

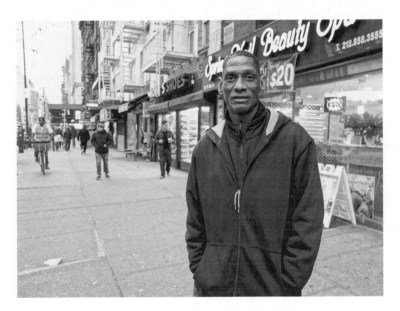

First Day Out of Jail

Undated Note:

O: "How much can one enter, I wonder, another's insides—
see through their eyes, feel through their feelings? And, does
one really want to . . .?"

THE MOVING MAN

When the lease on my first New York apartment came up for renewal, the landlord raised my rent. I could no longer justify what I would be paying for a small, sixth-floor walk-up, so I decided to move. I found a relatively inexpensive place on the East Side, a few blocks from the First Avenue L station. I took it on impulse—my default mode, I see now. Within days, I knew I had made a terrible mistake. The apartment was a cave. The building was a partying frat house. Pigeons lined every sill, cooing and shitting and grooming themselves, despite my shooing, as if to let me know they had been there long, long before me. What hit me just as hard was how much I hated my new subway lines. I came to dread taking the 4/5 from Union Square to work in the Financial District every morning; it was cacophonous and crowded and, more than most subways in my eyes, irredeemably grimy.

Worse, really, was the L, which I'd take home from Oliver's on the West Side. Not the train itself, which was fast and frequent, but what it represented. In that direction, the L is packed with people on their way to Brooklyn, whether going home or out partying. They always seemed remarkably hip and gay (in the original sense of the

word) and young, whereas I felt like an old man being taken away from where he really wanted to be.

I feel guilty now that I projected my unhappiness onto the subways. The L and the 4/5? They did right by me, getting me home and to work on time and safely, and each brought its share of sights and discoveries. While waiting for a 4/5 one mercilessly humid summer afternoon, I found unexpected refuge from the suffocating heat under a gigantic fan installed in the ceiling at Union Square. I'd never noticed it before. But there I stood, gratefully, as if in the final leg of a car wash, my sweat-drenched clothes getting a jet drying.

It was near that same spot on an equally hot day that I saw a young woman faint just steps from the platform's edge. She wilted in slow motion, but at the exact opposite speed two people came to her aid. By the time I reached the scene, she was in very capable hands, literally. There was a man cradling her head, who turned out to be a doctor, and at her side, holding her hand, was a preternaturally calm woman who looked like a yoga instructor. When the fainted woman came to, she looked terrified and confused, but the calm woman calmed her and the doctor doctored her, and in due time, the two walked her outside for some fresh air.

Crosstown moments come to mind too: Were it not for the L, I would never have met Pablo, the young Dominican who manned the Mister Softee ice cream truck parked outside the station at First and Fourteenth. Stopping for a cone and a how's-it-going always made heading home easier. At the other end of the line was Joseph, a disabled artist whose drawings I collected and whose dedication inspired me. If Joseph, wheelchair-bound, could get himself from his SRO hotel off Times Square to the Eighth Avenue station every day

to make and sell his work—even in the dead of winter—what excuse did I have for not practicing my art?

I had nearly given up writing at that point in my life, too preoccupied and distracted by my full-time job. Moreover, by January, I had begun to despair about my living situation. I couldn't face another year in that cave, and Oliver and I had decided that, for us, living together didn't make sense—it would not suit either him or me, each of us needing his own space. Perhaps the ride is over, I thought; the turnstiles that swung so freely are locked shut: Station Closed. But what to do, where to, next? To be a New Yorker is one thing, but to decide consciously to stay, to live out one's life here? That's another. I wasn't sure I had what it takes. By which I did not mean simply fortitude but something more, something less effable.

That is when luck or fate in the form of a New Yorker named Homer, fittingly enough, intervened. Homer, the doorman in Oliver's building, told me of a just-vacated apartment on the eleventh floor—three floors above Oliver's place. He let me see it. Many things about the place struck me as exactly right but, most of all, the light. The small apartment was window-lined. To the south, I could see a downtown cityscape, and to the west, a sliver of the Hudson River. Everywhere I looked, I saw life.

I have been here for six years now. I have not yet and expect I never will cover the windows with blinds or curtains. I'd rather not say exactly where in New York it is. All one needs to know is that, whether you live here, too, hope to, or are visiting, you and I may meet for a fleeting moment, perhaps today even, on a subway.

Just the other night, I had a nice encounter while heading home. Sitting near me was a man about my age sharing a two-seater with a suitcase, a duffel bag, a backpack, and a stuffed garbage bag. He

caught my eye (or did I catch his?); something in his beaten-down expression looked familiar. I turned off my iPod.

"What's going on?" I asked.

He shook his head dolefully. "Too much for one man to take."

"Yeah?"

That was all he needed—the conversational equivalent of a starting whistle—and he was off, telling me in a rush of words how he was supposed to move today and a buddy with a truck had promised to help him out. The buddy didn't show. And now here he was on fucking leg three of a solo relay marathon.

"That sucks, man," I said, "really sucks. But you know what's at the end of all this?"

He looked stumped, or just plain exhausted.

"A six-pack."

The Moving Man cracked a smile.

"Have one for me," I told him as I got off at my stop.

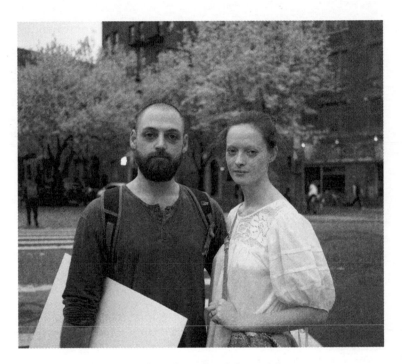

Couple on Seventh and Greenwich

NOTES FROM A JOURNAL

Undated Note—June 2011:

The difference between us in two words:

"Me, too," I say.

"I, too," O corrects.

———————————

6-28-11:

O and I at Miyagi, on "conversion experiences," as he calls them, life-changing moments, positive and negative, each listing his own: I tell him about discovering Joni and Joan Didion and Diane Arbus and Edmund White, and about the AIDS epidemic in San Francisco. And he tells me about Janáček and the Romantic composers—Schubert, Brahms—and Luria, and the community of the Deaf, and about losing his mother. And we talked about those we have shared.

We were eating outside. All at once, "Oh!" he exclaims, seeing a firefly, Tinker Bell-like at our feet.

"Isn't it amazing!"

"Yes, but don't—as I have told you before—eat one."

"Ah, the dreaded death by firefly . . ."

O nods his head very seriously.

———————————

7-5-11:

Ideas for O's birthday present:

- H. G. Wells or Somerset Maugham short stories

- Talking watch—@ Lighthouse for Blind

- *Star Trek: The Next Generation* DVDs

- Leather gloves

- Copy of the Koran

7-11-11:

Evening

Horse hooves on the avenue

Bring me to the window

Taxicabs lined up for gas

Pedestrians in a Merce Cunningham dance

And a woman, clearly lost

iPhone aloft

Stops the mounted policeman for directions

She listens as he talks

And points her the right way

The horse nods and trots off

8-24-11:

A long soak in a very hot bath:

"What's the temperature?" O asks.

I check his bathtub thermometer—a comically large contraption: "106."

He approves. "I've gone as high as 110," he says. "112, that's the limit, and 102 is too cool. It's interesting, isn't it, there's a very slim margin . . ."

I soak for half an hour, O at the side of the tub stroking my leg. I feel drugged, tranquil. At one point, I feel him watching me quizzically: "Why does one close one's eyes with pleasure . . .?" he wonders aloud.

After, I lie on a towel on the bed, naked.

He lies next to me, clothed. Only our hands, fingers, touching. The AC is on. I am glistening and wet with sweat, cooling down, which takes a very long time. We drowse and talk and look at the salmon-colored sky, but mostly don't talk, just touch.

"I feel like I'm always rushing," I say at one point.

O lets it sink in. "That you are," he says, then more quietly, "that you are . . ."

He runs a hand over my body. "You are *so* warm. Even a rattlesnake could find you."

"Yeah?" I look at him. He is staring at the ceiling as he speaks.

"They have infrared sensors in little pockets behind their eyes."

I smile. "Imagine that . . ."

"They're not in the lenses, I don't believe, but they can sense the warm blood of poor little mammals—no chance against those vipers . . ."

Now, he's off on another thought, as if on his psychoanalyst's couch, free-associating: "In England, there were motorbikes called the Viper and the Venom. Beautiful machines . . ."

O turns to me, puts a hand on my belly. "Yes," he purrs, "a beautiful machine."

8-26-11:

We are at the Brazilian restaurant when O suddenly asks: "Have you ever felt that a part of your body was not yours?"

I laugh. "This is why I love you."

He smiles. "Well?"

"*A part of my body not mine*: Uh, I'm not sure, I don't think so."

"If one did, one would know," he responds drily.

After eating, we rush back to listen to a live broadcast of Mozart's *Requiem* on the radio. Or, what we thought would be. It was Schubert instead. Ah, but Schubert—so romantic and grand: Lying on the bed in the dark, listening to his eighth symphony, in our underwear.

The radio announcer says that Schubert died at thirty-one.

O: "Do you think it makes it easier to die young, knowing

that you have already created enough masterpieces for a lifetime?"

"No," I answer, "no I don't."

———————

9-15-11:

7:15 P.M., O on the phone, without even saying hello: "Billy! Shouldn't one be on the roof? The sun is setting!"

I: "Yes, one should!"

O: "I will meet you there!"

I: "I will bring a bottle!"

———————

11-20-11:

We got stoned in what I call O's "opium den"—it's just his den, but it's now been christened with weed. We only take a puff or two, nothing crazy. To get stoned with him is to get a glimpse inside that incredible brain. Because of his blindness in one eye and poor vision in the other, his visual cortex— "almost out of boredom," as he puts it—becomes hyperstimulated by cannabis, and he greatly enjoys this visual fantasia.

I sat in the chair by the window, watching Eighth Avenue; he lay on the couch.

His eyes were closed, and I asked him what he saw behind his lids: "A Chinese baby." Pause. "A seal balancing something on his nose . . . A sort of science fiction flying

machine above a medieval forest . . ." Pause. "And you? What do you see?"

I closed my eyes, waiting.

"Nothing of the kind. I see patterns—black and a kind of dim yellow. A negative image of the Empire State and other buildings I've been looking at out the window. And then, a kind of kaleidoscope, but not colored."

"A negative image?" he inquired. "That's very interesting."

Several minutes of silence passed.

Suddenly he said: "Can one ever experience pleasure that is not attached to an object? *Pure* pleasure?"

I thought about this for a moment, marveling mostly that he had suddenly had this thought and voiced it. But I was not sure I understood. "What do you mean by 'attached to an object?'"

"Well, one can say, a piece of music gave you pleasure, or seeing a handsome face, or smelling something delicious. But can pleasure be independent of any influences?"

I hesitated but thought of a feeling I get sometimes where I am conscious of nothing but a sense of well-being. "Yes, I think so. I am feeling it now. Do you?"

"Yes, I do. And I think cannabis can bring this out."

I smiled. I am charmed that he always calls pot "cannabis"—I imagine Darwin would do the same. "Oliver, are you experiencing this now?"

His eyes were still closed: O watching his internal movies. "Yes, oh yes . . ."

"Oliver, is this not happiness? Is this pure pleasure the same as happiness?"

"I don't know. What do you think?"

"I think not. Pleasure, even if it's not dependent on an object, involves the senses—is sensuous. Pleasure can bring happiness, but happiness doesn't necessarily give one pleasure. So which is of the higher order of the two?"

"Happiness. Happiness is more complex."

"Agreed."

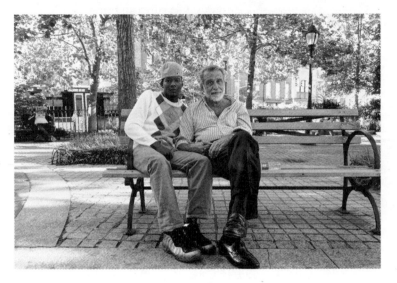

Jackson Square Park

FOR THE SKATEBOARDERS

I once said to someone that one doesn't come to New York for beauty.

I said that's what Paris, or Iceland, is for.

I said one comes to New York to live in New York, with all its noise and trash and rats in the subway and taxicabs stuck in cross-town traffic jams.

I didn't know what the hell I was talking about.

If there could be a chip implanted to track one's vocabulary, as miles logged are counted with those fitness bands people go around wearing, I'm sure *beautiful* would be in my top ten most-used words. I am always saying that that's beautiful or this is beautiful. The thing is, beauty comes in unbeautiful ways here.

One Sunday morning not long after moving here, I was standing on Sixth Avenue at Eighteenth or so waiting for a light to change when I heard what sounded like the low rumble of snow plows. But this wasn't winter, I thought to myself, the streets are clean, and then the light turned green and no one walked or drove through the intersection. One couldn't. Sixth Avenue had been taken over by a brigade of boys on skateboards—dozens and dozens, maybe a hundred or

two, I'm not sure, there might have been a girl or two as well; it was all a blur. The sound of their wheels on the street was all but drowned out by their whoops and hollers and the barking of dogs made mad by these four-wheeled paw-level intruders. Some boys had their shirts off and waved them in the air like flags—the flags of an invading army, here to spread a message of freedom, fleetness, speed, wind, wit, youth, grace, the anarchy of pure joy, and *fuck you.*

I was not the only one on the sides left openmouthed and clapping spontaneously. In a flash—far too soon—the skateboarders were gone, no doubt taking over downtown. The light had turned red by then, and we were still stuck standing there on two feet on the sidewalk.

I wondered what it was all about but never investigated. Someone's always selling something or someone, and if it was for a promotion of some kind—for a brand of skateboard, let's say—or being filmed for a music video, I didn't want to hear about it. The only evidence I have that it really happened and was not something I dreamed up is a cryptic message I sent to my friend Jimmy from my phone as I walked home: "Beauty stops traffic," I texted.

Jimmy's lived in New York a lot longer than I have; I love how he responded: "I know," he texted back.

PART II

ON BEING NOT

DEAD

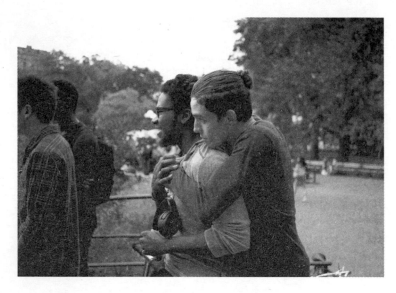

Washington Square Park

NOTES FROM A JOURNAL

12-17-11:

O: "I thought being old would be either awful or trivial, and it's neither."

I: "What makes it not awful and not trivial?"

O: "Aside from you, thinking and writing."

———————

1-1-12:

Just before midnight, I taught O how to open a bottle of champagne, something he had never done before: sweet to see the joy and surprise and fear on his face as—*pop!*—the cork exploded. He had insisted on wearing his swimming goggles, though, just in case.

———————

1-22-12:

O and I watch the view of Eighth Avenue from his apartment; it is cold and gray outside. He has his monocular to his eye, and zeroes in on a smokestack.

"The smoke is doing exactly what it must. It looks like a universe being formed; embodying the air currents." Pause. "Some has dipped down, curiously, to look beneath the roof."

He could be narrating a film.

"It's budding off now, like smoke-lets, like a hydra . . .

Dissipates . . . trails . . ." He puts down the monocular. "*Trail*: Nice word." O turns to me. "Do you feel on a trail?"

"Now I do," I reply. "For a long time, I felt off it."

O nods.

"A trail is *for* one. But one has to *make* it," he says.

Minute after minute passes as O and I watch out the window. I feel serene. I don't have to ask; I know O does as well, his quietness speaking to it.

"'*Old men ought to be explorers*,'" he suddenly says. "I like that line."

"Auden?"

"Eliot."

Undated Note:

Getting dressed for a walk, O habitually announces each article of clothing as he puts it on: "Coat. Hat. Gloves. Muffler . . ." But then he stops himself. "Do you say 'muffler' here?"

"Here? What do you mean, 'here'?" It's as if he had just arrived in America, I point out, as if he were just visiting from England for a few days.

"In fact, I've been here for fifty-two years, since the summer before you were born!"

Here before I was born: This still surprises me. Sometimes I feel older than O.

3-17-12:

O: "I don't know if a passion for symmetry is an intolerance of asymmetry. Do you?"

I: "I think one can be passionate about both. I think one can embody both."

O: "Good. Very good."

———————————

4-7-12:

A not untypical dinner:

O snipped the ends off the string beans with his cuticle scissors, "coiffing" them for the steam. I trimmed the broccoli. We shared a gigantic carrot, passing it back and forth between us, while having some of O's specially mixed tea—a blend of smoky Lapsang Souchong and brisk Darjeeling.

We left the salmon to marinate. I read the paper, O went into the bedroom and did fifty-five of his signature crunches— exhaling on the first, then holding it five seconds on the second. O likes things to be in fives. I grilled the salmon atop the stove, five minutes each side, and made some toast from leftover challah bread.

I opened a bottle of wine.

I was feeling blue, I didn't know why.

To divert me, cheer me, O told a story of a Tourette's patient who was a surgeon and would smoke while exercising every morning. This made me laugh; I hadn't heard it before. After eating, O got up and found the story in *An Anthropologist on*

Mars—his large-print edition. As I lay on the couch, he sat at the table and read the entire story, from start to finish, in the most animated voice, lavishly drawing out the more unusual words. I peeked over the couch a few times to watch him reading, the book just a couple inches from his face. It's amazing he can read at all—he's so nearly completely blind. I clapped when he came to the end.

We returned to the kitchen. His wine was "too sour," so he added a packet of artificial sweetener to it—"Much better"— and drank it down. We talked about this and that, and then I said I needed to go to bed. He absentmindedly reached for the bottle of port, uncorked it, and took a swig. "Nothing like port," he murmured.

Next morning, O reported that he had had a dream in which he was at a "charming little café in the shadows of two giant oversized mushrooms." On the menu? "Two kinds of fern salad and a carrot salad with 7,217 different carrots." He'd drawn the number (and a picture of the mushrooms) on the kitchen whiteboard when he woke in the middle of the night.

––––––––––––

4-8-12:

O: "Are you conscious of your thoughts before language embodies them?"

THE THANK-YOU MAN

One evening, I headed out to see Hailey's band at a bar in Brooklyn, not the kind of thing I'd normally do with work the next day, but how often does one have a friend who has a band playing at a bar on a summer Thursday? Just outside my front door, I crossed paths with a tall black man wearing a black suit and tie and riding a silver bicycle—a picture of elegance, an angel on Eighth Avenue—and sensed I'd made the right decision.

The subway car was as packed as at rush hour. Face-to-face with a kid with his nose in a Kindle, it struck me that sometimes what one gets—and gets to keep—on public transportation is not an experience but an unforgettable expression. When the subway came to a stop, snapping the kid out of whatever world he was in, he looked at once startled, confused (*what stop is this?*), anxious, irritated, and finally, relieved. His face went blank, he returned to his reading, and I was left to marvel: This kid had no idea he was born a century too late to be a silent-film star.

I got out at Bedford and began following the directions I'd jotted down earlier. A main street had been blocked off for some reason, so now the directions no longer made sense, and I didn't have a map app

or GPS on my phone. I took my bearings. Something in the air smelled like summer from my childhood—mown grass, gasoline, the dirt of a baseball field. I heard the crack of a bat hitting a ball, and I followed the sound.

I took a left, then a right. At the end of the street, I spotted a guy sitting on a couch positioned on the dock of a warehouse. I approached. His feet were up; two beer bottles were at his side. This looked like the reward at the end of a long day.

"Nice night," I commented.

"Yeah, just taking it all in."

I looked over his shoulder at the jumble of boxes and machines, trying to make out what this place was. He told me it was a bunch of things—a foundry, a forklift repair shop, artist studios, storage. I asked if I could take a look. He didn't answer right away; he was considering the request. I thought he'd say no. Finally: "Sure, just . . . be careful."

Now I was really curious. I hopped up. The farther in I went, the more interesting it got—a junkyard of seemingly useless stuff, it spoke of broken machines and dreams and failed inventions and road trips that ended with shot carburetors. The scent in the air was of dirt and engine oil and sweat.

I didn't linger, not wanting to outstay my welcome. "Really cool," I said as I hopped back down.

"Thank you," he replied. He took a swig.

I looked at him. He seemed lost in thought. I wasn't sure if I should say what I wanted to say next, but, what the hell: "And that's a good smell."

"Thank you," he said.

I loved that he took this for what it was—a compliment on his

patch of the world, odors and all. I asked him directions to the club, and he obliged.

I told him to have a good night and went on my way.

At the door of the club, the security guard asked me for my ID. "You think you look too old just to get in?" he teased.

I dug it out of my wallet and he took a look. "Fifty?"

"Fifty-one."

"Don't look it."

"Don't feel it," I replied. "What about you?"

"Guess," he said.

I eyed him. "Thirty-eight."

"Nope. I'm older than I look."

By then, a very young-looking girl was at the door, fishing in her purse for her ID, at the guard's request. She looked underage, frankly. "Can you guess his age?" I said to her.

She looked confused. Wasn't this about *her* age?

She got frazzled. She couldn't decide. She was taking this very seriously. She didn't want to offend him, but she also really had no idea. She said she could never judge age, she never thought about it.

"Just guess," the guard prodded, "just try. How old am I?"

She studied him carefully. "You're . . . comfortable," she finally said.

This thought floated in the air.

"That is such a good answer," I said.

"Yeah," the guard agreed, "very good."

"That's how he looks. I don't know his age, but he looks comfortable."

The guard checked her ID; it was legit. We all introduced

ourselves: Raymond, Billy, and Crystal. Crystal told me to come by the bar, where she'd be working, and she would give me a free Heineken.

"Cool."

———————

HAILEY — O's ASSISTANT by day, musician by night—and her band were fantastic. They played as if they were in a stadium, not a two-bedroom-sized bar. I stayed too late and had one more beer than I should have. When I left, I passed by the warehouse. The Thank-You Man was still there, accompanied now by two other people and several more bottles of beer.

"You're still here," I said, not knowing what else to say. All three looked at me calmly, openly, as if thinking: Of course we're here, where else would one want to be?

"Yeah," he answered, "just making sure everything is operating correctly."

"I feel safer already."

"Thank you," he replied.

I said good night, and the three said good night in return.

As I walked back toward the subway, I looked at the sky and there were great white cumulus clouds visible. Bright clouds at night, backlit by the moon, have always thrilled me. They seem so surreal, and yet make you feel very much like you are part of a *planet*, part of a *universe*, not just in a random city. Then I did something I do some-times when maybe I feel a little lost or need to remind myself of exactly where I am in my life: I sort of clear away the junk and do a quick metaphysical inventory:

"Consciousness that this is a planet," I whispered to myself, "and of the sky and the clouds.

"Consciousness of my mother, who loved clouds and who died a year ago tomorrow.

"Consciousness that I am lucky to be here.

"Consciousness that I got myself here.

"Consciousness that I am thankful."

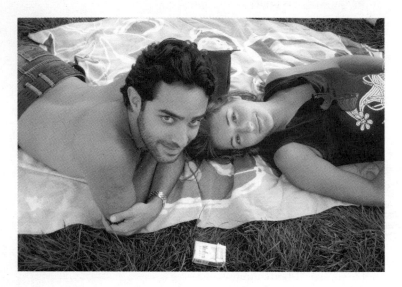

Lovers on the Grass

NOTES FROM A JOURNAL

Undated Note—2012:

O: "I sometimes think things are not enough until they are too much. There is no in between for me."

———————————

6-17-12:

I met a go-go boy tonight. He was on a break, downing a Red Bull at the bar where he works. His name was Vinnie, and he was twenty-five.

"I put myself through school doing this, dancing," he told me. "F.I.T.—I just graduated."

I congratulated him and shook his hand, still wet with sweat. "And what amazing things can the world expect from you next?"

He smiled. "Photography—fashion photography—the sickest."

He took out his iPhone and showed me pictures from a recent shoot. I was surprised by how good they were—highly stylized; Art Deco meets the 1980s, somehow suggesting a Madonna influence, I commented.

"Exactly. Madonna saved me. My first album was *Ray of Light*, and I loved the photography. I knew then, that's what I wanted to do."

The go-go boy asked me about myself. I told him what I do, about the piece I have in the *Times* this weekend, my books.

He said he wanted to read the piece in the *Times*. "It sounds romantic."

"It is romantic," I told him, "deeply so. You're a romantic, too?"

His helpless expression answered.

Vinnie told me he'd grown up "on the Island"—Long Island, a skinny kid with thick glasses—"I'm practically legally blind, honestly; I can't see anything when I'm dancing"—and dreamed about one day living in New York. Madonna was part of his dream.

"And you made it."

"I did."

"Here you are."

"Here I am."

He left to do a set on the go-go box. Later, when he took another break, Vinnie came and found me, and we picked up where we'd left off. First, though, he felt obliged to tell me, "I have a boyfriend."

"As do I, and he knows I'm here. It's all good."

"Actually," he corrected himself, "two. I have two boyfriends, a couple, and I am their boy. See?" He showed me the dog tag around his neck, engraved with both their names.

I could not imagine such an arrangement working well, but who knows? "That's fantastic," I said, "tell me about it."

And so he did. The go-go boy with the glorious body told me all about his boyfriends and his belief in polyamorous

relationships, but there was something troubling him. "We had a fight yesterday—"

"—That happens, bound to happen."

"No, this was a big fight. And, maybe because tomorrow is Father's Day, it's really worrying me. I mean, these two— they're sort of like my dads; my parents did nothing for me— and they help . . . give me direction."

I nodded, thinking about how Steve and I used to have blowouts once or twice a year, usually over something minor—"cleaning out the pipes," I used to call it—and even O and I squabble occasionally. I pulled Vinnie in close and hugged him: "It's going to be okay," I said into his ear, just making myself heard above the disco music, "I promise." I held him for what seemed like a long time. I had no awareness of people watching us, if they were. Finally, I let him go. I stuffed a twenty-dollar bill into his jockstrap.

"Go," I said to the go-go boy, "dance." And I headed home.

Oliver's Desk

4-22-12:

O, tidying his desk:

"I specialize in a very large number of a very few things—
magnifying glasses, spectacle cases, shoehorns, rubber bands . . ."

Undated Note—April 2012:

I found O standing at the piano, where he was taping together
pieces of sheet music, enlarged on the copy machine so he can
read them. I watched him silently as he narrated while he
worked. It was all very, very, very complicated of course. He
had fourteen sheets and was "very puzzled" about what had
happened to sheet #12 or why sheet #8 was slightly smaller
than sheet #9: "Oh, oh, oh," he said very seriously, "I think we
have a problem . . ." He was thinking it all the way through,
and envisioning the worst.

I watched as he tried to snip an uneven edge off one sheet;
because of his blindness, he was missing it entirely, scissoring
the air very, very gently, and there was something so touching
about this—the care with which he was doing it; I know he
felt that he must be very delicate with the paper, with the
music, must not hurt it. After a bit, I gently moved his hand,
so that he cut the paper as he wished. He said thank you.

From there, he, with my help—"Would you mind, please,
putting your finger there? No, not there! *There.*"—began
Scotch-taping them together on his long table. One after the
other, after the other, each "hinged" with a piece of tape, then
taped again from behind. Occasionally, he would get
distracted and start talking about something entirely

different. He noticed that the blinds were uneven and asked if I would even them out (like cheese or pieces of scrap paper, everything had to be symmetrical in his world).

I reached to do so, but he stopped me with a cry, "Take heed of the ferns!"

"'Take *heed*'? Who talks like that?" I teased. "Queen Victoria?"

He laughed hard, as he rushed to protect his "little darlings" from me. They were just barely new, on the sill to get some sun. (Later he would explain exactly how they reproduce—the eggs and the sperm, as if I were in a sex-ed class from the nineteenth century.)

Finally, we were done with the sheet music. He asked me to fold it up—"like an accordion"—and then he began playing. It was one of Schubert's songs. And he played it all the way through, from left to right—I unfolding it at his comically barked commands: "Now!" "Now!"—and he played it well, and it was lovely.

———————

5-17-12:

A balmy night; taking a walk through the playground on Horatio St.; seeing girls playing four-square, and boys shooting hoops, one of whom is particularly striking—tall and lithe and tanned, shirtless. He runs, dribbling, and dunks a basket, then immediately steps onto a skateboard and from there glides across the entire playground in a gentle arc, perfectly balanced, all the while reading texts on his phone.

———————

6-4-12:

On the street: A woman dressed—and completely covered—
in black. She wears a pair of sunglasses. For some reason, I
turn to see her from behind. She has a second pair of
sunglasses on the back of her head.

———————————

From my window: the triangle park, and the oblong traffic
divider with two trees. I see a couple standing at the tip of the
divider. Not young—maybe forties? She wears a long
summer dress and is blonde. He is bald and has one hand on
her ass. He pulls her in close and kisses her. They came out
there to catch a cab but end up making out in the middle of
traffic instead. So sexy. Finally, he flags down a cab. They are
going back to his place, I imagine, to fuck.

This is New York in the summer.

———————————

Undated Notes—June 2012:

Garbage overflows from trash cans. The streets are filled with
garbage and dirty water. The air stinks. But there is a warm
pinkish-gold glow on the streets from the setting sun.
Gorgeousness. We are closer to the sun in New York, I think.

———————————

A Sunday: seeing a guy scraping off the mess of ugly flyers
taped to a streetlight pole—not a maintenance worker, just a
guy from the neighborhood. I watched for a while then asked

him about it. He said he comes out every other week or so. "Remember, you have the legal right to rip them down," he explains. "Go to NYC.Gov/sanitation." He spray paints the pole to its original gray color. "Today I have gray and green. Sometimes I get red, too—for the fire alarm poles."

––––––––––––

7-29-12:

In bed, O reads to me from Darwin's *The Voyage of the Beagle*, one of his favorite books, which I'd found in his library: "*This volume contains, in the form of a Journal, a history of our voyage, and a sketch of those observations in Natural History and Geology, which I think will possess some interest for the general reader . . .*"

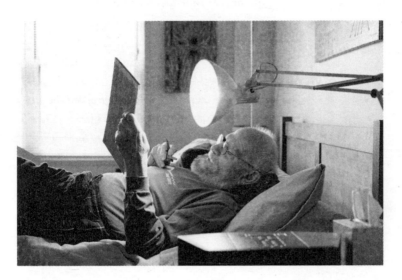

At Home

THE SAME TAXI TWICE

It's not like on TV—taking a taxi in New York City. It's almost never as interesting or colorful as they make it look, except for when it is—and when it is, stuff happens that you could never make up. I once had a cabbie from Sri Lanka who looked so young one might have legitimately wondered if he was old enough to drive. Turned out, he was twenty-five. He told me he'd been in New York for two years and was saving up money to bring his wife and parents to New York. He hadn't gotten married yet, though. He hadn't even met his future wife; his parents back home would arrange a marriage at a given time. We discussed some details about how the courtship would go, and then he told me, "She has to be a virgin."

I hadn't asked about this, but I agreed. "Definitely, yes, she should definitely be a virgin." I was coming from drinks with friends, and I was kind of buzzed.

We came to a red light. "And I have to be, too," he added.

"A virgin?"

"Yes," he said solemnly.

Hold on, I thought, is that really a good idea? Shouldn't someone know what they're doing in this situation?

"So, let me get this straight: you've never had sex at all?"

"Never."

"Not even almost? Never fooled around—maybe here in New York . . .?"

He shook his head.

I thought about this through a couple streetlights. I could never even guess how many times I've had sex in my lifetime, and with how many different people. I can hardly remember what I like about it most. But this much I could tell him: "You are going to love it. You're going to really like it a lot. It's amazing."

The cabbie from Sri Lanka shot me a look. "Really?"

"Really. You have nothing to worry about."

It is the enforced intimacy of being in a cab, an enclosed space, for a finite period of time, which makes such conversations possible. I've sometimes wondered if the screen between driver and passenger, not unlike that in a confessional booth, adds to this impression. You might say things you would never say otherwise, or do things you'd never do, knowing you'll never see them again.

But this is not always so.

One night a cabbie picked me up on Wall Street, and we had a nice chat on the FDR. As we approached Eighteenth and First, where I lived at the time, he spoke up: "Drop you off on the right, middle of the block?"

"Yeah, how did you know that?"

"I remember you; I've given you a ride before—last year." He looked at me in the rearview mirror. "Sunny," he said.

Sunny. Yes: The name that went with the face, the demeanor.

What are the odds of having the same taxi driver twice?

He told me: There are 13,800 cabs in New York City, he had been driving for eighteen years, dozens of fares a day, and this had never happened to him before.

"How about that . . ."

We said good night and goodbye without much fuss.

"See you again, Sunny," I said.

I LOVE those late-night rides home. I remember once catching a cab way uptown somewhere after I'd spent the better part of the night with a man who had made me dinner—pot roast and apple pie. I still smelled like him.

It was very cold outside, and with a punishing wind; some were saying it was the coldest day in the history of New York City (an endearing hyperbole). I asked the cab driver if the cold was good for business.

"Yes," he murmured. He had a bit of an accent.

We were flying down Second Avenue, hitting all the lights. I'd been struggling to get my seat belt on—goddamn seat belts in taxis, they only work about half the time—but finally gave up; I trusted him to get me home safely.

"It must be fun," I said dreamily, "driving like this when the streets are empty . . ." I was thinking if it were me behind the wheel, I guess.

It took a moment before his reply came: "No, not fun. Stressful. It's always stressful."

I was surprised at being mildly rebuffed. "Of course—must be, I can't imagine," I said, trying to make up for my presumptuousness.

"Traffic's good here," he added, "but in Midtown? Crazy right now—a game at the Garden."

A picture came to mind of men in suits and ties, fat cats and their ladies in diamonds, with front row seats on the floor at the Garden, a place improbably filled with flowers of every kind. "You must get totally different customers depending on where you pick them up," I said, as if it were something fabulous and interesting, something I'd love to see right now—so much so that I thought about asking him to turn around and head toward Midtown.

The cab driver took this in. "No," he said, "not really—different people everywhere."

Two strikes. Oh well. But I liked that he was actually listening to my questions and thinking about them, not just agreeing with me.

I watched Manhattan rolling by—the cold city and the street-lights. I imagined I was on a ship—a cutter ship in the Arctic.

"Cross Thirteenth—is that what you want?" he asked.

"Yeah."

We stopped at a light, a long line of cars. Even at that hour, cross-town traffic was slow.

"You're like a psychiatrist in this job," he offered, suddenly, unprompted, "people tell you all their problems, all kinds of things, stories." With his face lit by the red brake lights of the car in front, he looked like he was running through a few of them in his head, the wilder ones, I supposed.

"Usually, not New Yorkers"—here he made that gesture of sealing your lips—"they don't say much. But tourists? Tourists talk."

"So, do you like it when people talk, or no?"

"Oh yes, I do, I like to meet people."

"You don't mind that I'm asking you questions?"

"Not at all, boss."

Boss. That is one thing: I do not feel like a boss. And even if I did—who likes their boss? It doesn't seem like a compliment. But I get that all the time in cabs.

"I've only lived here a few years," I told the cabbie, "moved here four years ago."

He looked at me in the rearview. "An infant, like a child, four years old—in city years," he said with a grin. "I've got a daughter your age."

I laughed. "How about you—how long have you lived here?"

"Twelve."

"Almost a teenager then!" He turned and gave me a smile. "From where? Where are you from originally?"

"Africa," he said with a punch of emphasis. "Morocco—Casablanca. Like the film, you know—Humphrey Bogart?"

I watched his face: he was thinking about Casablanca—or maybe Ingrid Bergman.

"So why here? Why New York?"

"Make money, for my family. My wife and kids are back there."

This was almost impossible for me to imagine—the people you love most living so far away. No one making him dinner. No one waiting up for him at home.

"I think it's good," he added, "for them—it's too hard here. My kids, if they want to come later, when they're older, that's okay. For me? I don't know—I came for the American Dream or whatever."

He really did say that. People do say things like that—in cabs, at night, at least.

He laughed bitterly.

I felt many things—I felt badly for him; I felt guilty about my prosperity, my good fortune; I felt bad for New York, bad about America. But I also felt lucky that he and I had met.

We approached my street. "You can cross here, I'm up at the corner. Right side."

I felt like I wanted to keep talking almost, like we'd just gotten started. I told him my name, and asked his. He said, "Abdel."

I have a friend in San Francisco, Frish, who keeps a running list of the first names of every cab driver she's had: Cheikh, Akhtar, Alfredo, Mati, Sufian, Manuel, Mohammed, Juan, Raphael . . . I find that very beautiful. I wish I'd started doing that when I moved to New York.

I paid the fare and gave him a bigger tip than I usually would. Abdel turned to me and said with all sincerity, "We will meet again."

It was almost spooky, how he said it.

"What do you mean?"

"A ride. It happens. When it's meant to—"

I opened the door, but sat there for another second.

"—and if you ever want to go to Casablanca, I will tell you where to go."

"Thank you, Abdel."

"You're welcome, boss," he said.

Fifth Avenue and Thirteenth

NOTES FROM A JOURNAL

8-26-12:

I, listening to Björk on my iPod;

O, reading and writing in his travel journal;

We: drinking champagne on a flight to Reykjavik.

I look over and see O making a list in his journal. He tells me he is writing out all the elements that are NOT present in the human body:

He

U

B

Be

Al

Si

Ar

Sg

Ti

V

Ni

Ga

Ge

As

Br

Kr

Rb

Sr

Y

Z

When I ask, he names each of them, following my finger as I go down the list. He interrupts himself at one point: "They like to be remembered and recited like this."

"They?"

O nods.

He could not look more delighted, and it's not because of the alcohol.

Listed separately, under the heading, "No or infinitesimal," are the exceptions. He goes on to explain the difference between organic and nonorganic chemistry. I do not—and expect I never will—understand half of what he is saying.

———————

8-28-12:

Björk invited us to her home in Reykjavik for lunch—a remarkable afternoon; O said it best: "Everything was unexpected."

The two met a couple of years ago when Björk asked Oliver to appear in a BBC documentary about music, but they had never spent time together socially. And in fact, O knew very little about her work up until shortly before

we made this trip. I got a DVD compilation of her music videos and conducted a crash course in Björk for him. O sat on the edge of his bed, inches from the TV screen, as he needs to in order to hear properly, and watched without stirring, mesmerized especially by the visuals, for ninety minutes. Because of his face-blindness, which makes it difficult for O to recognize people not only on the street but also in movies and on TV, he'd sometimes ask, "Is that Björk?" Or, "Which one is Björk?" A swan dress one minute, robotic gear the next, her constant changing of costumes and hairstyles utterly confounded him, but he was deeply impressed by her artistry.

We pulled into the driveway at the back of Björk's home and I saw her through the kitchen window. She looked to be in the middle of a task, concentrating. A simple hedge fenced the house. There was a child-sized table and chairs in the front yard, the setting for a tea party. We didn't see a path, so we parted a hedge awkwardly and made our way to the front door. She answered. In my memory, she curtsied on greeting us. Of course she didn't, but her air of modesty and respect in greeting O had that feeling. She ushered us into the dining room, where a table was set. Björk introduced us to two friends: James, who's English, and Margarit, Icelandic, both of whom had striking red hair.

Björk's hair was up, held by a barrette with blue feathers. She wore a simple tunic made from several different kinds of colored and patterned fabric; she may have made it herself. She wore white pants under the tunic and wedge sandals. Her face: unlined, no makeup, pretty; eyes the color of jade; lush, jet-black eyebrows, shaped like two feathers.

I walked into the kitchen, where she was preparing lunch. The wallpaper was a photo print of different women's elaborately braided hair—the hair of goddesses. She was completely at ease, unpretentious; more than anything she seemed eager to be a good host—wanting to make us feel comfortable and, like a mama, get us fed. We chatted for a little bit. But I was too nervous to say what I would have liked to say—how much her music had meant to me, especially after Steve died.

Björk urged us to sit and eat. The chairs were carved from tree stumps. The tablecloth was embroidered with seashells. On the table: warm, salted mixed nuts in tiny dishes. Almost immediately, she brought out a steaming pan of baked trout, a salad, and a bowl of boiled potatoes—"I like it with the skins left on," she said, almost apologetically, "don't you?" O and I nodded.

Conversation was lively. We talked about Iceland, about Oliver's new book, *Hallucinations;* about her CD, *Biophilia,* and her new projects. She told us that she'd recorded *Biophilia* (its name inspired by Oliver's *Musicophilia*) in the lighthouse I'd spotted the night before when I was chasing down the sunset. Björk said she had a calendar in the kitchen with the time for the tide going in and out, so they would know when they could get to the lighthouse—and how long they would be "stuck" there while the tide was in. She laughed. "It was really, really good, because it forced me to work; I couldn't leave if I wanted to." She mentioned that she'd inquired about buying the lighthouse. That didn't work out, but she thought this was for the best. "A lighthouse is for everyone."

After eating, Björk led us from the table, through a little door, and to the stairs. These were not stairs in any conventional way. Oliver—ever the naturalist—knew exactly: "Why, these are basalt stones! This looks like a stairway carved out of a wall of basalt!" Björk nodded. Adding to this remarkable sight: The railing in the winding stairway was made of whale rib bones.

Björk smiled and helped Oliver up. "And this"—she pointed to the shimmering lamp hanging overhead, dropping into the stairwell, "actually my daughter and I made it out of mussel shells. It wasn't supposed to be permanent, but . . . we like it."

She wandered into an upper room, and we followed. There, she showed us two custom-made instruments, a celeste and what looked like a harpsichord. Both had been modified somehow through instructions from a program on her Mac. I could tell that O was completely lost as she explained how this worked. Yet it was then, right then, that I realized how much she and O were alike—fellow geniuses, incredibly, intuitively brilliant—while being at the same time such an unlikely pair of friends.

Back downstairs, Björk brought out a gooseberry pie, with berries picked from her own trees. She'd made it with her daughter the night before. "As she was the cook, of course she had to have the first piece," she said, pointing out the missing wedge. She served it up in a nice slop—topped with fresh, plain Skyr, which has a sour bite to it—along with coffee and tea. The tea set was out of *Alice in Wonderland*—each cup literally half a cup, sliced in half. "I've learned that these are for right-handed people, these teacups," she says, "or I learn

who is left-handed by watching them try to drink from them." She giggled.

We finished the pie. I looked at Oliver's watch and saw that it was almost three thirty; we'd been here three hours. Oliver signed an advance copy of *Hallucinations*—"You will be the only person in all of Iceland with this book"—and I gave her a copy of one of mine. "For Björk, with gratitude," I signed it.

THE WEEPING MAN

I left work one night at five fifteen and headed west on Fulton to catch the uptown 4/5 at Broadway. The sidewalk was packed thick with commuters. I felt weary and aggravated by the slow pace of the crowd. "Come on, people," I muttered under my breath, "let's move." Just as I said this, I noticed something not right: a young man, two or three people ahead of me, crumpling. A building caught his fall. I came to his side. He was pale; his face contorted; he clutched his arm. He was dressed in a suit, as if he had just left his office on Wall Street. "Are you okay?" I asked. "Are you sick? Do you need help?" I wondered if he was having a seizure. I felt for my cell phone in my pocket, ready to make a call.

He didn't answer. He was Asian and, for a moment, I wondered if he didn't speak English. I repeated myself: "Are you in pain? Do you need help?"

"No, I'm okay," he said, and then began weeping. I looked around, not sure what to do. Passersby were watching. The young man stood and began walking slowly, still weeping all the while. I stayed by his side.

"You sure you're okay?" I asked. "If I can do anything to help—"

He nodded, so, though reluctant, I went on my way, taking the steps down to the subway station. When I rounded the corner, I saw he was behind me. Our eyes met. I slowed my pace so he wouldn't lose track of me in the crowd. He followed, through the turnstile and onto the platform. He looked so distraught, his face a rictus of pain. I had a bad feeling, I just did, frightened that he might do something to harm himself. He came and stood next to me; he cried quietly but didn't speak.

Fortunately, a train arrived immediately, and I ushered him onto the car. Commuters rushed through, pushing their way in, pushing hard; you can't believe how crowded a subway car can be at rush hour.

He grabbed hold of a pole with both hands, so tightly his knuckles went white. He began crying again. The subway car was packed so tightly that I was pressed right against him. I told him my name and asked his. "Kenneth," he mumbled, saying it with derision.

"What's going on, Kenneth?" I whispered.

He took a deep breath. "It's all gone wrong!" he spit out. "My entire life."

Had he lost his job? Lost a fortune? Gotten his heart broken? I didn't ask. I put a light hand on his shoulder and let the train's hum answer him.

We rode in silence for a while.

He looked up at one point. "You're a good person," he said brusquely. He tried to say it nicely, I could tell, but somehow it didn't come out that way; it sounded like a mean accusation. It was actually sort of funny. I couldn't help but smile.

"Listen," I told him, "I have had days like the one you are having." I told him how sometimes I used to go out to the pier at Christopher Street when it was empty, just to have a cry. "It's hard."

The car was packed tight yet completely quiet but for the sound of a young man in a nice suit and tie, crying. I looked around and saw alert, concerned faces—people not wanting to intrude but at the same time listening.

An Indian woman seated nearby caught my eye. She mouthed to me: *Is he okay? Does he want to sit down?* I asked Kenneth, but, no, he wanted to stay put. The Indian woman squeezed through and joined us. There we were, three strangers steadying ourselves on the same subway pole. Pressing up against us from all sides, it seemed, were hundreds and hundreds of subway riders, in this car, and in the next, and in the next, in both directions, like a long retaining wall that keeps a whole mountainside from sliding down.

She asked Kenneth if he had a place to go, people to be with tonight. He was going home, he answered. He had to get off at Grand Central to get the train to Yonkers. She offered to go with him. He refused her help—No, no, he said—but she insisted she would be happy to go.

I thanked her. "I have to get off at the next stop. You'll make sure he gets home safe?"

"Absolutely." She introduced herself to him, her voice like a song.

The subway stopped at Fourteenth Street–Union Square. I wished Kenneth well and thanked the woman again and stepped off.

A Touch-Up

NOTES FROM A JOURNAL

9-16-12:

In Brooklyn, waiting for the subway back to Manhattan at the Graham Avenue stop, I happened to see a somewhat older man—nice-looking, bald, maybe fifty-eight, fifty-nine—do a double take as a young woman walked by in a short skirt. He looked over and saw that I'd seen him seeing her. He smiled. "Do you think she knows how pretty she is?" he said to me.

She was just far enough away that she couldn't have heard him.

I watched her, retreating with her friend; she was a knockout, at least from the back, she really was. "I'm not sure. Why don't you ask her?"

He shook his head. "Nah, too old for her." Pause. "I'll tell another one that tonight."

"A date?" He nodded, and as if in preparation for whatever he had going on later, he began doing a waltz—one-two-three, one-two-three. This was the sweetest thing to see, like that time I saw the actor on the subway practicing his lines, a rolled up script in one hand. The man kept dancing. The subway came. At the far end of the platform, the girl and her friend got into one car. Here, the waltzing man and I got into another.

Do you think she knows how pretty she is?

9-30-12:

Why is it hardest to write when there is so much to say?

Let me rephrase: It is hardest to write when there is so much to say.

Wendy Weil, my agent, has died. She was found at her home in Connecticut on Monday; apparently, she'd had a heart attack while in bed—she was surrounded by manuscripts, I was told ("I have so much reading to catch up on," she'd said when we spoke on Friday afternoon—we had just finalized my new book contract).

I am so sad to lose this friend, not just a friend but also a mentor. I can hear her saying so many things to me, always supportive: how she'd say, "O-*kay*," a hard stress on the second syllable, drawn out, say it several times, as you told her what you wanted, maybe what you wanted answered by a publisher or editor. How when she said something like, "This is you at your very best," lowering her eyes and looking at you dead-on through her bangs, as she did about some of my *Times* pieces, I knew she really meant it. How, after lunch with that editor from Simon & Schuster, we decided to walk back to her office rather than take a cab. We saw an expensive chocolate shop near Rockefeller Center—"Their chocolates are divine," she said—so we stopped and bought five, one each for Emily, Emma, and Anne back at her office. Wendy and I ate ours as we continued walking.

10-2-12:

> This morning on a crowded subway, I spotted a young black woman dressed entirely in shades of pink: pink pants, pink ruffled blouse, pink jacket, pink ballet slippers, and pink clutch handbag. She was wearing giant round sunglasses. I thought about how Wendy enjoyed hearing stories of my subway encounters and sightings. I had my iPod on, as I always do, and was listening to a Neil Young song, his voice plangent and impossibly beautiful. I started to weep. I put on my sunglasses. I took a breath. I didn't really want to be crying on the subway. I zeroed in again on the young woman in pink. I loved that she had dressed up in what must be her favorite color. Her lucky color. I imagined she was going to an interview for a new job. She was looking in my direction. Although I couldn't see her eyes, I was sure they were meeting mine, tears falling. "You are going to have an amazing day," I told her, purely through my thoughts. "You look fabulous." The subway came to a stop. The woman in pink stood and smiled back at me as she exited.

10-8-12:

> Sunday night: attended a concert with O at St. Bart's church: Mozart's *Requiem* Mass, performed by an orchestra composed of Weill Cornell med students and doctors. One of the doctors recognized O and ushered us to some good seats. Exquisite performance. Saw Linn and Ved Mehta afterward. A rainy night.

> Talking in the car on the way home: O said, listening to the *Requiem* he couldn't help thinking about, in a way

"picturing," seeing, his own death and feeling "not troubled in the least—not serene, but . . . *as if it is the right thing at the right time*. And so it will be."

I looked over at him and nodded. I took his hand.

Back home, we reheated the salmon and vegetables we'd made the night before, set the table, opened a bottle of wine, turned on the radio.

Cleaning up the kitchen, O, washing the dishes, commented: "One feels they want to be cleaned. One feels they appreciate it." The dishwasher wasn't completely full, so he added already-clean coffee mugs and glasses to it, "so they have company."

He is endearing and hilarious this way, how he invests objects such as pots and pans and the table we eat on (rushing to put a protective place mat down so as not to "hurt" it) with feelings. He views most things—and I do mean *things* (pots, the alarm clock, his fountain pens, the piano, and most especially, books)—as having life to them, a nature . . . while at the same time acknowledging that this is absurd, ridiculous.

Earlier, over dinner, O talking about his late friend Gaj— Carleton Gajdusek, a Nobel laureate in medicine—with great excitement and conviction, comparing him to Goethe, of whom it was said, O told me, "He had a *nature*. A nature."

I thought I knew what O meant—O, who has always disliked being pigeonholed, typed, as simply one thing or another, doctor or writer, gay or not, Jewish or atheist, etc.—but I wasn't completely sure and prodded him.

"A nature," he repeated, as if that was the only way to say it. "He wasn't this or that, fitted with so many labels, an

'identity,' like people today, but all aspects of him were of a piece—this is who he was, not *what* he was; a force of nature, I suppose."

10-21-12:

Finding O at his desk, hunched over a yellow pad, writing, I sat across from him. He is working on a new "little piece"— an atheist's take on the "absurd" idea of an afterlife. He's titled it, "Seeing God in the Third Millennium."

I like it already, I tell him. He reads for me the many pages he has written—twelve or fifteen. I am with him, every word. It reads fluidly, authoritatively.

Outside: a racket of horns blasting on Eighth Avenue; there must be a traffic jam. I can see the river of red lights. Oliver doesn't notice anything. He has come to the end of what he has written. He is not sure where to go next. A phrase suddenly comes to him: ". . . a handsome apprehension of heaven . . ."

I say it sounds like Shakespeare.

"Close—sort of." It's Sir Thomas Browne, he tells me. "Help me find it, please," he says, and I follow him into the small room in the back, where he has novels, plays, and poetry shelved—literature, not neurology or science books. He is at the B's, studying titles, and immediately becomes agitated. "Now, where is it? *Religio Medici*, I know I have it." He gets impatient when he's excited; I half expect him to stomp his feet.

I am hugging him from behind and scanning the shelves: Borges, Burgess . . .

"I used to have all of Thomas Browne. All my books . . ." His voice trails off wistfully. "Oh, what has happened . . .?"

"Are you sure it's in here?" I go into the living room and find the B's. There: four or five volumes of Sir Thomas Browne.

"Excellent!" O exclaims. "Aren't you clever! What would I do without you?"

"You'd go days without your keys or glasses—or your Thomas Browne."

He settles back down at his desk. "Let's have some wine," he says.

I return with two glasses. He is paging through the fragile book, reading aloud his own annotations and underlined passages from fifty or sixty years ago. At last, he finds what he was looking for—"Not in *Religio Medici*, but in *Christian Morals*. I had forgotten. And on the very last page . . ."

He reads it to himself first, savoring the words, and then aloud to me: "'Reckon not upon long life: think every day the last, and live always beyond thy account. He that so often surviveth his Expectation lives many Lives, and will scarce complain of the shortness of his days. Time past is gone like a Shadow; make time to come present—'"

"—So gorgeous," I murmur.

O skips ahead a bit: "'And if, as we have elsewhere declared, any have been so happy as personally to understand Christian Annihilation, Extasy, Exolution, Transformation, the Kiss of

the Spouse, and Ingression into the Divine Shadow, according to Mystical Theology, they have already had—'"

He looks up, beaming.

"—Ah, and here we have it: 'an handsome Anticipation of Heaven.'"

———————————

10-30-12:

The day after Hurricane Sandy, and the blackout that hit last night hasn't lifted. How eerie it is, seeing Eighth Avenue without its daubs of red, green, and yellow lights; the street empty but for one or two people; fire trucks and ambulances and police cars converging at Fourteenth. The rumbling of the wind. Sirens.

O is lying on the couch, I am in the easy chair. We crack the windows; strong puffs of air cool our feet. We have opened the bottle of Veuve Clicquot left over from his birthday; we figure it will get warm otherwise. We listen to the transistor radio; people calling in with reports and sightings, fear in their voices. O recalls the blackouts during the war, during his childhood, and the first major blackout in New York— November of 1965—when he had to walk from Bronx State back to Christopher Street; it took him six or seven hours.

Here we are, how many years later? Oliver is seventy-nine, I am fifty-one. We have no power, no running water, no phone service, no gas, no heat.

We drink champagne. We say a toast. We count our blessings.

Freddy and Hollywood

ON BEING NOT DEAD

One night I called Oliver and told him to meet me on the roof of our apartment building. I had pulled together a simple dinner—roast chicken, good bread, olives, cherries, wine. We ate at a picnic table. I'd forgotten wineglasses, so we traded swigs out of the bottle. It was summer. The sun was setting on the Hudson. Neighbors were enjoying themselves at nearby tables. The breeze was nice. The surrounding cityscape looked like a stage set for a musical.

What is the opposite of a perfect storm? That is what this was, one of those rare moments when the world seems to shed all shyness and display every possible permutation of beauty. Oliver said it well as we took up our plates and began heading back downstairs: "I'm glad I'm not dead." This came out rather loudly, as he is a bit deaf. Even so, he looked surprised by his own utterance, as if it were something he was feeling but didn't really mean to say aloud—a thought turned into an exclamation.

"I'm glad you're not dead, too," said a neighbor gaily, taking up the refrain. "I'm glad we're all not dead," said another. There followed a spontaneous raising of glasses on the rooftop, a toast to the setting sun, a toast to us.

I suppose it's a cliché to say you're glad to be alive, that life is short, but to say you're glad to be not dead requires a specific intimacy with loss that comes only with age or deep experience. One has to know not simply what dying is like, but to know death itself, in all its absoluteness.

After all, there are many ways to die—peacefully, violently, suddenly, slowly, happily, unhappily, too soon. But to be dead—one either is or isn't.

The same cannot be said of aliveness, of which there are countless degrees. One can be alive but half-asleep or half-noticing as the years fly, no matter how fully oxygenated the blood and brain or how steadily the heart beats. Fortunately, this is a reversible condition. One can learn to be alert to the extraordinary and press pause—to memorize moments of the everyday.

I think now about that summer night on the roof, and how many people I have known or loved that I've lost since then: my mother, three friends, two neighbors, and my agent, Wendy, who was like a second mother to me. Her many friends and relatives came together for a memorial one afternoon last week. It was beautiful, joy-filled. Irishman that I am, I wept all the way through. Oh, well. I've come to believe that a good cry is like a car wash for the soul.

Afterward, I started walking, walked past a subway entrance on Lexington and kept going. It was dark by now, and cold. But the autumn night receded and Lex magically turned into Fifth as I called to mind that warm afternoon spent with Wendy in June. We'd had lunch and decided to walk back to her office rather than take a cab. She was about a head taller than me, so whenever I glanced at her it was against a backdrop of blue sky and high-rises and American flags fluttering on Fifth Avenue. I felt like I was on a dolly-cam, seeing her

through the lens of a movie camera. She wore a big smile and a sleeveless dress. We were talking about how much we both loved New York—she as a native, I as a newcomer—and all the while, I was aware that I was glad to be here right now and wanted to remember as much of this as I could. And I do. The short clip of our walk plays on a continuous loop.

When I got home, Oliver called. "Come downstairs," he said, "everything's marinating." We set the table and opened a bottle. He'd grilled salmon and steamed peas. For dessert, we split an apple; a perfect meal. We turned on the radio. It was "Beethoven Awareness Month" on our classical radio station, and it began playing Op. 133, the "Great Fugue" with which he had originally ended one of his late quartets. I am not well versed in classical music; had I not heard the announcer, I would have guessed it was something contemporary—even composed this very day. Oliver told me that in Beethoven's time the piece was considered almost unintelligible by listeners and so demanding technically as to be nearly unplayable. Conversation came to a stop and we just listened, the music at once chaotic and violent, mysterious and gorgeous.

Behind Oliver, through a large picture window facing north, Eighth Avenue unfurled as far as the eye could see. I have this thing where sometimes I try to catch the moment when all the traffic lights on Eighth align and turn red, their number multiplied countless times by the brake lights from stopped cars and taxicabs. It doesn't happen often at all, traffic lights seeming to have their own sense of time, and Oliver never quite catches it. So I watch for the two of us. Finally: "There, there it is, see?"

He turns to find a fiery red Milky Way on the streets of Manhattan. And in a blink, the lights start turning green.

ON A TYPEWRITER

I don't know what to say
Says O
So he lets his fingers say
What they must be thinking:

This is the first time I gave typed on ages !!!
The typos being not typos
But notes from a dying language
Qwertyuiop
l t ud rrr jpe miy gos mp
;ry ud der how it goes mpw

The starts and stops and flights of thought
Mimicking his

————————————

M,u good fremd BILLY has put in a new ribbon
He types

2345670asdfghjkl;]xcvnm,.rqwert67890-=

Should I then return to using te y typewriter ?

I think this is, in a q er tai n way, beautiful

I THINK YJIS IS, ON A V CERTAIN WAY, BEAUTIFUL

THIS IS, IN A CERTAIN WAY, BEAUTIFUL

THIS IS BEAUTIFUL

THIS

IS

—3-1-13

AT THE

SKATEBOARD PARK

I walked up to the skateboard park off the West Side Highway at Twenty-Second Street. I didn't just end up there while walking, as I sometimes do; I went there directly, expressly. I am drawn by the sound, by the sight—the skateboarders diving and floating and flying; the way they avidly watch one another from the rim; their rituals, their unspoken rules—and by the feeling it gives me.

"Cool, isn't it!" said a scrappy-looking boy who had been watching me watch all of them. Had he read my mind, or was it an expression on my face?

I nodded. "So cool. Mesmerizing."

We spoke through the high metal fence that surrounds the park. I was standing on the western side, one foot on one of the round pedestals put there for viewers, the other atop the concrete bearing wall. I held onto the fence with both hands. The day was gorgeous, high forties, maybe even fifty degrees, sun. "Wish it would stay like this all winter," I overheard one of the skaters say. The park would be closed for the winter in a few days.

"Some of these guys—they're *good*, man," the boy said, glancing over his shoulder. "*You* know, *you* been watching."

This kid was small, five foot six or so, and skinny. He'd only skated once or twice so far, and he was not nearly as good as any of them. But in a way, I was glad to see this; it would be easy to take for granted how good most of these boys were. But the canyon on the west side was very challenging, with its sheer, twenty-five-foot drop—dangerous. None of them wore helmets or padding.

It seemed like an especially good group today—somehow of a higher caliber; there was a certain intensity in the air. Each had a different style, depending as much on body type as on level of fearlessness. One kid used his arms to help accelerate, sort of like how you use your feet to pump on a swing. Another, part Asian, had an especially elegant way of moving, sinuous. A shorter stocky black guy was rock-solid. And then there was a kid who looked like an Arab prince. He was extraordinary, the way he would ride the rim, then swoop down into the canyon and then fly up, touch the front of his skateboard, land back on it, dive down again, fly back up, tap the rim—extraordinary. No panther could be more accurate or delicate, elegant, than these creatures—the gentle stepping off, stepping back on. A few times, there was spontaneous applause. I'd never heard that before. These boys were not just skating for the fun of it, the thrill; they were competing for "who's best."

"Who is best?" I asked the boy.

"That one there?" he nodded toward the taller black kid in the checked flannel shirt. "He's confident. Smooth."

"Yep," I confirmed.

"And that little kid?"

I knew who he was talking about, I'd seen him earlier—practically a tyke, with long strawberry-blond hair.

"He's pretty damn good, he's got air."

I was picturing the kid flying off the back canyon wall, disappearing behind a cloud.

"But that guy back there—" he nodded at the slightly older white guy, a dude in his early thirties, with a goatee and a loud mouth—he'd been trash-talking some of the other guys before and after he rode and he was himself really good—amazing loops and air, no crashes; fast. "That guy? He is *tough*." He did seem really tough—like he had taken a lot of falls in his life and never stopped riding. I was behind a fence, but even there, I felt a little afraid of him. (Earlier, he'd come by and shown another guy where the fence was broken at the top and could be pulled out. "This is where we come in at night," he'd said.)

Now this kid, talking to me through the fence, started talking trash, too, suddenly adopting street language, foreign to me, and talking about how he was going to do pops and tricks, grabbing at his crotch as he spoke. I wished I had a translator. But even if I had, it wasn't what he was saying but *how*, almost like an MC, rapping; it was plainly for show. I wasn't sure that he wasn't flirting with me. I had to chuckle.

I asked him how long he'd been skateboarding.

"Only a year, year and a half. I used to come here at eight in the morning, and just sit right there"—he pointed to the rim on the other side of the canyon. "It was empty, no one here. Then they started coming. And I started to hang out, and learn some tricks." He paused. "I don't got a board—"

"So how do you skate?"

"Friend let me use one—sometime."

He must not have any money, I realized.

"But I just got this deck," he said, "someone's old board." I hadn't noticed that he had been crouching on it this whole time—a skateboard without any wheels; a tiny stage set. He picked it up, turned it over in his hands. It was messed up. Both ends were splintered, like it had seen a hell of a lot of crashes. "Gonna get myself some *trucks*. Have myself a *car*."

Trucks, I had picked up earlier, are wheels; and the skateboards themselves? *Cars*: boys' cars. Now I got it. I asked him what made a good skateboard anyway.

He picked up the board and proceeded to explain its anatomy. "See this here?" He was pointing to a very shallow dip, an inverse bump, about four inches from one end. "That's where you *pop*." His voice had taken on a serious, authoritarian tone. "You know?"

He must have seen that I didn't know what he was talking about. He got onto the board and shifted his weight and, in an instant, used his feet to pop the deck off the ground. He did it three or four times, studying my face all the while until I clearly got what he was talking about.

He crouched back down, proceeding with his lesson. "That little curve there, that shows you where the tail of your board is."

"The tail?"

"The end—that's the end of your board. So this is the front." He showed me the totally banged up and splintered anterior.

"The head?" I asked.

He thought about this. "Okay, the head."

I had interrupted his flow. "Now, boards are all different layers sandwiched together," he continued. "See this, when you look down

the length of it?" He presented a cross-section view. "This one is—
one, two, three, four . . . five . . . six, six layers. See?"

I saw.

"But some of 'em, really good boards, are nine layers. Those are
heavy fucking boards, and if you've got a guy who's got some good
solid weight, you can really fucking fly. But you see," he was bringing
the narrative back to himself now, "I'm kinda small, I've got really
small feet." He put the deck back down on the ground and stood on
it. I was now at eye level with his feet and the board. He did have
small feet, maybe size six. He couldn't have weighed more than
125 pounds. "So, for me, this is just about perfect, a six-ply board,
about eight and five-eighths wide. And you see this tread here?" He
was talking about what looked like sandpaper covering the deck.
"This is what keeps you sticking to the board." He demonstrated
this quality, standing on the deck without wheels on the rim of the
canyon where skateboarders better than he could even dream of
being were diving and flying. In that moment, he looked smooth,
confident.

"All you need is some truck—"

"And I'll have a car," he replied. It was like we were harmonizing.

He picked up his banged up deck and looked me in the eye and
smiled. "So: Skateboarding 101, sir. That's right."

"Thank you very much."

"S'alright."

He wandered away. I kept watching. I remembered how once I'd
brought Oliver here on a hot August afternoon. It was a long walk
for him, but he had been fascinated. "It's a living geometry, isn't it?"
Oliver whispered, dazzled by the sights. He mused about how the
ancients would have admired them—these boys who "describe

curves in hyperbolic space" with their lithe bodies. "They may not have read Euclid, but they know it all," Oliver said.

There seemed to be more crashes. They were getting tired. But they were trying to beat the sun, get as many skates in as they could, outrace their own shadows. Soon, they'd have to park their boards for the winter, snow on the streets of New York.

On the periphery, a few girls watched. I understood why. This was a mating ritual, the boys peacocking for the girls who would take them to their beds, if they desired them.

Some boys were packing up for the day. The crashes were taking their toll. More than one was nursing a sore wrist. A kid with shaggy long hair limped up and fell into a heap on the other side of the fence near where I was standing. He hadn't noticed me. He had a bleeding cut on his arm. He took a long draw from a bottle of Coke. He took out his iPhone and checked messages. He hiked up one of his pant legs and rubbed his ankle. He lit a cigarette.

Finally, I decided to go home. By coincidence (or was it?), the scrappy kid came out of an exit and began walking with me, his deck wedged under an arm. We talked about how cool it was—the park. "I got a broke toe and a broke arm, but when I'm in there, I forget," he said.

Now, the pain was setting in, darkness falling. But where he'd been before—behind that fence, where boys live in the air? There's no pain there, nothing's broken.

He asked me where I was going, and I said I was going home. I wasn't sure, but I again thought he might be flirting with me. It wouldn't be the first time a street kid had tried to hustle me.

There was a pause, in which anything might have been said. And indeed, what he said next was completely unexpected: "A dollar for a slice of pizza?"

It took me a good two seconds before I understood how wrong I'd been. I had to laugh at my middle-aged vanity. I reached for my wallet. "Sure, of course, that's a reasonable price for the lesson you gave me."

"Cool, man. I was working up my nerve to ask for that."

That takes nerve? I thought. What about diving down those concrete walls? "No problem. What's your name?"

"Cube."

"Cube? Really?"

He grinned, found out. "Chris."

I asked Chris how old he was.

"Twenty-two. I am new to everything," he added; it both did and did not sound like a non sequitur. "New to skateboarding, new to New York, new language."

I took this in.

"What's your name, sir?"

"I'm Billy."

"What is it again?"

I took off my sunglasses for the first time all afternoon. He looked straight into my eyes.

"Now I see you," he said. "Billy. Thank you, Billy."

A Small Parade

NOTES FROM A JOURNAL

11-15-12:

I saw a young woman on a Manhattan-bound subway train wearing a knockoff Louis Vuitton head scarf and false eyelashes long enough to make a daddy longlegs envious. Her look—a sort of Sally-Bowles-does-Brooklyn—was complete with a matching knockoff L.V. handbag and umbrella.
She was seated next to a young man as dashing in his way as she was adorable, but she took no notice of him at all as she was completely absorbed in a paperback titled something like, *Becoming a Practical Thinker*.

I had an impulse to tear the book from her hands.

"Don't do that!" I wanted to say. "Practicality will not get you where you want to go. Believe me—I speak from experience!"

Looking back, every life-altering decision I've ever made has seemed, at first blush, misguided, misjudged, or plain foolish—and ultimately turned out to be the opposite: every seemingly wrong person I've fallen for, every big trip I've splurged on, every great apartment taken that I could not realistically afford. And, really, what is pursuing writing but a case study in an impractical career . . .?

———————————

12-30-12:

On a red-eye to Reykjavik for New Year's Eve:

Leaving New York, the city looked embroidered in gold thread.

Now, clouds and stars, and what sounds like a hymn:

"*Craving miracles . . .*" Björk sings.

1-1-13:

Supper of Skyr, biscuits, and tea in our tiny hotel room. Recovering. Snow falling.

Last night, a New Year's Eve dinner at Björk's, was like being safely in the middle of a very happy war; a huge bonfire on the beach across the street from her home encircled by people singing; fireworks going off in every direction, from every home, all night long, and culminating in a chaotically beautifully, or beautifully chaotic fireworks display at midnight in the town square.

As if the sky were full of shooting stars.

As the church bells pealed twelve times.

As the ground was snow-covered, white, the floor of a cloud.

As everyone kissed and hugged one another.

Bottles of champagne and Brennivin, an Icelandic schnapps— clear and strong.

As the New Year began.

1-13-13:

> Home a week and still adjusting, wishing in some ways we were still in Iceland. The gentleness of life there suits me . . . suits us.

> People even swim gently there, not kicking and splashing— never—as swimmers do in New York, where all seem to be training for triathlons in their minds.

> From Reykjavik, we took a little prop plane up north to Akureyri. It was already dark at three in the afternoon, and we went directly to the community pool. I swam some laps then stood in the shallow end. I saw an almost miraculous sight: in the adjacent lap pool, where a swim team was practicing, the outreaching arms of swimmers doing the backstroke and crawl—there must have been twelve or so— and from my pavement-level view, all I could see were the motions of the arms, so elegant, smooth, rising, arcing, falling, like the hands of a dozen clocks, all set at slightly different times, in slightly different time zones.

1-23-13:

9:40 P.M., 17 degrees;

Such a clear night, you can see stars in Manhattan.

The gurgling sound of my heater.

The comical *kerplunk* over and over of cabs on Eighth hitting a metal plate on the avenue. I imagine the plate itself: feeling every single hit, bemoaning its fate, putting up with it . . .

I go to my window, watch the dance down below:

How every step taken by every person seems to have a purpose, to be part of a larger purpose, a rhythm moving us forward, life forward; what appears random isn't—the choreography of pedestrians:

An old man's gait changes; suddenly he's scampering across the street.

A girl dashes, frantic.

A woman in a wheelchair smoothly rolls.

And all the while: *Kerplunk. Kerplunk. Kerplunk.*

A WOMAN WHO KNEW
HER WAY

I once met a young woman at a party who almost got into a fight over directions.

That's pretty much exactly what she said when she came up to me: "I almost just got into a fight with a guy out there over directions." She glanced at the sidewalk. She was still incensed. She had long blonde hair and wore a newsboy cap. I didn't know her name. We hadn't met yet. She wasn't really even talking to me. She said what she'd said to the young woman to whom I had been talking. We hadn't met yet, either. I had been standing in a corner by the window; it was a very crowded room; the first woman asked me how I knew the guys who were hosting this party.

"I don't really know them," I admitted. I told her I liked the shop, I liked the clothes here, I lived in the neighborhood.

Only the last part was true. I had actually just been out taking a walk, looking at the Christmas lights on people's houses and fire escapes—it was a clear, cold night, about ten o'clock—when I came upon this shop at the corner of Perry and West Eleventh. It was a surf

shop—surfboards visible through the large plate-glass windows—
that much I knew. The little shop was filled with people, a holiday
party clearly, and the party had spilled out onto the sidewalk; it
looked warm and inviting. *Why not?* I thought. I opened the door
and slipped in.

I headed right to the bar like I knew exactly where I was going. I
was handed a drink, a sweet and very strong holiday punch. Five
parts rum or something: perfect. Everyone at the party seemed to
be outstandingly good-looking, women and men alike, so much
so one might wonder if this was a criterion for getting invited. I
pushed my way through the crowd, around the circuit once, then
retreated to a corner to take it all in. That's how the first woman and
I started talking. But my claim that I liked the shop, liked the clothes,
hadn't satisfied her. "You don't surf?" she said.

I considered lying, saying, "Yeah, sometimes I surf," or, "I used to
surf, but not anymore." She might have believed that. I could've told
her about California, where I used to live. But in the instant I knew
my lie would somehow be found out. So I said I liked the clothes—
they also sold T-shirts and sweaters and stuff. She took a sip of her
drink then said, "You really don't surf?"

That's when the blonde in the newsboy cap walked up. The two
said hi, like they knew each other, and then she said the thing about
almost getting into a fight over directions.

It was very noisy so I wasn't a hundred percent sure I'd heard
right. I asked if that's what she'd said.

She nodded, like it was the most normal thing in the world. "I was
so pissed off. We're talking and he nods in that direction"—she
pointed toward the northeast—"and he says he's going to a party in
the East Village, just sort of nods his head. You know?"

I nodded.

"And so I say, 'That's not the East Village. If you go that way, you'll run into, like, Sixth and Twelfth.' Right?" She was talking to us now.

The other woman and I looked out the window toward where she'd pointed, and then we both said, "Yeah, right."

"'That is *not* the East Village.' And he just looks at me and does this dismissive thing with his hand, as if saying I'm a girl and I don't know what I'm talking about. He shows me his phone, his fucking phone, and says the phone says that's the East Village. And it really pissed me off. I mean, I've lived here five years—"

"I know what you mean," I interjected, "you have managed to live here for five years. You have earned the right to give good directions. You don't need a phone telling you."

"Exactly. I *know* how to get to the East Village, and that is not how. I don't care what your fucking phone says." She sighed, took a long sip of the fruity drink. "I just had to walk away; I almost wanted to hit him." Suddenly the taste of the rum punch hit her; I could see the recognition on her face. "Wow, this drink is really strong."

The other woman and I agreed. We had figured this out a couple sips ago: we were all very quickly getting very buzzed. Then the blonde in the newsboy cap looked at me with a puzzled expression as if it suddenly struck her that she had been talking to me all this time but didn't know me. "What's your name?"

"I'm Billy."

"I'm Liz."

"I'm a fan of anyone who gives directions," I added.

She nodded, and smiled mildly. We stood there for a minute not

talking. It was really loud. The other woman looked out at the crowd, scoping where to go next; she clearly didn't want to be standing there talking to two people about the value of good directions, especially since one of them was old enough to be her dad. I couldn't blame her.

Liz asked how I know the guys who were giving the party.

I said what I'd said to her friend: I like the store, I live in the neighborhood.

"He doesn't surf," added the other.

I could have kicked her. What I wanted to say was: *A surf shop in Manhattan? For real?* It must be a front by some clever guys to pick up cute girls.

Liz asked where I lived exactly and, when I told her, she asked if I'd been impacted by Hurricane Sandy. I told her how I was—no power, water, lights. She said she was similarly affected, but there was not a trace of complaint in her voice. It was like she was now standing up for the storm. I'm not saying she was pro-storm, but let's say, pro-storm-experience.

The other woman had a look on her face like she didn't understand a word either of us was saying.

"I mean it, I'm really glad. To go without power or water or heat for a few days? It gave me a feeling for what it's like for a lot of people every day. Every goddamn day!" She paused to take a sip. "It transformed me. It really did. It transformed me."

By now, the windows behind us were all fogged up, it was so hot in there and so cold outside. Suddenly she stepped up onto the banquette, and she used her finger as a pen on the fogged-over glass. In cursive letters, she wrote, "Love Liz."

She did it slowly and carefully; they were the most elaborate

capital letter L's—very fancy, with exaggerated curls, like a young girl might do when practicing writing her autograph in her journal.

As she stood up there, I began thinking about how I happened just to wander in here, by chance, without an invitation, without a thought, but also not without feeling welcomed, and how I had ended up connecting with this spirited blonde woman with improbably nice handwriting. I thought about how few people nowadays really value getting good directions from someone, how they'd sooner believe their phone, and how few of us have really nice handwriting anymore, how this is no longer valued, because we communicate mostly by e-mail and text, and rarely write letters or postcards or in handwriting on fogged-over windows.

I told her how beautiful it was. You could see the lights of the city sparkling through the letters.

Liz stepped down. I gave her my drink to hold. I stepped onto the banquette and, using my finger as a pen on the fogged-over glass, I added my autograph to hers: "& Billy."

I took my glass back. "Cheers," I said, and the three of us toasted. "Here's to knowing your way. Here's to knowing New York."

Liz put her head back and finished her drink until the ice in the plastic glass fell into her mouth. She licked her lips. She said she had to get going.

I asked her where.

"That party in the East Village."

She said I should come but I said thanks, no, not tonight.

I watched her walk out and, as she passed by him, say something to the guy on the sidewalk. I could just imagine.

I slipped out the door and headed the other way.

Sam at His Newsstand

NOTES FROM A JOURNAL

2-6-13:

On a crowded 1 train up to 168th Street after work. I have my iPod on but notice an elderly woman nearby motioning to me and saying something. I take off my earphones. "Excuse me?"

"Would you like my seat?"

I demur, and ask why she offered.

"Because you look so tired."

How sad is that?

———————————

2-9-13—11:15 P.M.

"I hope I get a good night's sleep and then have a rush of thoughts, as I did this morning," says O. "It is very delightful when that happens—all of them rushing to the surface, as if they have been waiting for me to become conscious of them . . ."

I help him get ready for bed—"de-sock" him, fill his water bottle, bring him his sleeping tablets, make sure he has something to read.

I: "What else can I do for you?"

O: "Exist."

———————————

2-10-13:

Thank You, Snow

Thank you, Snow, says O

Echoing Auden thanking Fog

For keeping us in

The low rumble of a plow on Eighth

A man with a camera fixed on the sky

Trying to capture a blizzard

Streetlamps tripled in the double-pane windows

The silent comedy of delivery boys on bikes

Even still

We eat sea bass and apples

And take a bath

I first, then he

Sharing the water

104 degrees

While sipping shots of Brennivin

And cool down before a wide-open window beside the bed

When was the last time you tasted snow? I say

And scoop a handful from the sill

———————————

2-17-13:

A meteor has fallen to earth, I hear on the TV news. It's good to be reminded that we're not in charge. That we live in a solar system.

I bundle up and go to the roof of our building. It is bloody freezing—the wind chill is below zero.

I count exactly half a moon and a hundred stars.

The Empire State, lit in red, white, and blue, and the Chrysler, in its creamy crinoline, peek out from behind other buildings and seem somehow to say hello.

I can imagine why that meteor pulled away from its orbital belt and crashed to earth. The lights alone here are so inviting.

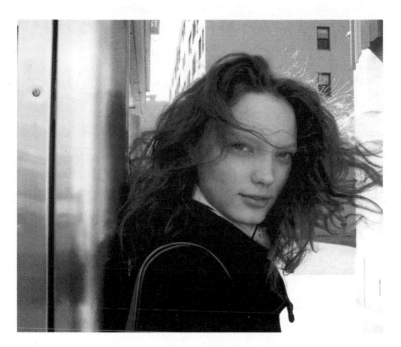

Beauty on Eighth

DRIVING A SUPERMODEL

Oliver and I went to a small chamber orchestra concert at the Irish-American Historical Society, a jewel box of a building directly across the street from the Metropolitan Museum. He knows the Irish gentleman who organizes these concerts, Kevin. They feature students from Juilliard. Very intimate. Unpretentious. Free of charge. A handful of people in folding chairs—maybe forty. Kevin had saved seats for O and me in the front row. Just as he was making his introductions, a woman rushed in by herself and plopped onto the cushy rose-colored sofa right next to our seats: Lauren Hutton, the model from the seventies: I recognized her instantly by her gap-toothed smile and slightly crossed eyes. Now in her late sixties, still beautiful, her face naturally lined. And, one couldn't help but notice, she had a big bruiser of a black eye.

The concert began with no further ado, and we all sat back and enjoyed the program—Brahms, Haydn, Ravel—by these enchanting musicians. Even if you were deaf, it occurred to me, you could still "hear" every note, so expressive were they—moving with the music, delicately interacting with one another by glance, their faces expressing the colors and tones they were creating with their

instruments—eyes widening or narrowing, smiling, pursing lips, necks craning, as if moving the music forward. I found myself thinking back on how healing music has been for me over the past six years. *Beauty is a balm to grief,* I once wrote.

With the final note, Lauren Hutton was the first to pop up and give the trio a standing ovation. "Do you have a fan club?" she sort of yelled above the clapping; it was a little startling, like someone yelling in a church. "I'm starting your fan club. You're fantastic, you're going places!"

The musicians bowed shyly and departed.

There was a small reception afterwards. Nothing fancy—two bottles of San Pellegrino and a couple bottles of wine—but no bottle opener. O and I were talking with Kevin when Lauren Hutton walked up to us holding the Pellegrino bottle: "Do one of you kind gentlemen have an opener? Even a knife would do—I could pry it open with a penknife."

"Why don't you use your teeth?" I said to her.

She laughed and smiled that famous gap-toothed smile. "I could. I could have once, but . . ." she wandered off. The bottle got opened somehow. Eventually she circled back and poured water for everyone. She overheard Oliver talking to Kevin about his new book, *Hallucinations,* which was coming out in a couple weeks. Lauren leaned across the table and listened intently.

"Hey doc, you ever done Belladonna?" she asked. "Now there's a drug!"

"Well, as a matter of fact, yes, I have," and he proceeded to tell her about his hallucinations on Belladonna. They traded stories. Eventually she began to figure out that this wasn't his first book.

"Are you—are you Oliver Sacks? *The* Oliver Sacks?"

Oliver looked both pleased and stricken.

"Well, it is very good to meet you sir." She sounded like a Southern barmaid in a 1950s Western. But it wasn't an act. "I've been reading you since way back. Oliver Sacks—imagine that!"

Oliver, I should note, had absolutely no idea who she was, nor would he understand if I had pulled him aside and told him. Fashion? *Vogue* magazine? No idea . . .

The two of them hit it off. She was fast-talking, bawdy, opinionated, a broad—the opposite of Oliver except for having in common that mysterious quality: charm.

Somewhere along the way, she explained the black eye: A few days earlier, she had walked out of a business meeting at which she'd learned that she had been "robbed" of a third of everything she'd ever earned, and in a daze walked smack into a scaffolding pipe at eye level on the sidewalk. She didn't seem too bothered by it: *Shit happens*.

I looked up and saw that the room was empty by now but for Kevin and us.

"Well, gentlemen, I'm going downtown. Share a cab?"

"Uh, we have a car," I said.

"Even better. Much more civilized. I'm downtown."

How could one refuse? "Let's go, shall we?" I said.

Lauren Hutton offered Oliver an arm and we walked slowly to the parking garage. I pushed things out of the way in the backseat; she tossed in her handbag, and dove in. She immediately popped her head between our seats—the three of us were practically ear-to-ear. Her incredible face blocked my rearview mirror. When O took out his wallet to give me a credit card for the parking, she spotted the copy of the periodic table he carries in lieu of a driver's license. This prompted a series of questions about the periodic table, the elements,

the composition of the very air we were breathing. A dozen questions led to a dozen more, like a student soaking up knowledge. We talked about travels—Iceland, Africa—and Plato, Socrates, the pygmies, William Burroughs, poets . . . She was clearly intensely curious, life-loving, adventurous. In passing, she said something about having been a model—"the only reason I did it was so I could make enough dough to travel"—but otherwise didn't say anything about that part of her life.

I am terrible with directions in New York, and she was not shy about telling me where and how to drive—"left here, right there . . ." Traffic was thick, so it took quite a while to get downtown. Eventually, we reached her address, or close enough.

"Well, gentlemen, it has been a true pleasure. I cannot thank you enough. This is where I exit. Goodbye—for now." And she was gone, as suddenly as she'd arrived.

Oliver took a breath as we headed west and home. "I don't know who that was, but she seems like a very remarkable person."

NOTES FROM A JOURNAL

3-21-13:

Finding O writing letters and listening to the Bach festival on WQXR—"I can't tear myself away," he says. He burrows his head into my abdomen and talks as I scratch his neck. He tells me how he'd slept, of his dreams (all "dull"), and of an article in *Science* about genetic variation that led to the Ruffled Grouse's ruffled head.

"I *wish* I could take a crash course in genetics," O says.

———————

Undated Note—March 2013:

A heavyset young black woman is squeezed into a spot at the end of a bench near the door on a Brooklyn-bound 2 train. She is probably going home from work. She has her iPod on and her eyes closed—she's clearly dozed off to sleep; you can see it in her slack face. She hugs a big chunky, bejeweled leather purse to her chest.

Sitting next to her is a small, rail-thin, young white woman— Eastern European?—who has a little boy in a stroller at her feet. The mother's eyes are closed. The little boy is about two. He's fidgety, as if he's just awakened from a nap and eaten some sugar. He eyes the woman's purse. He starts sort of swatting the purse, swatting at whatever is dazzling him— the colors, the rhinestones. Maybe he's deliberately trying to get her attention—anyone's attention. The woman feels something at her hands, brushes it off, her eyes still closed, as if it's a fly.

The little boy loves this. He starts slapping back at her hands. The young black woman cracks open one eye to see what the heck is going on. All she sees, I imagine, is this little hand— bothering her. She pushes it away. He pushes back. He's laughing now. She opens both eyes narrowly, and at first looks pissed but then can't help smiling. She's sort of giggling, like, "You little rascal, I'm gonna get you!" but also still half-asleep. She flicks his little hand away. He's giggling now, too, and wants to play more. But finally, she tires of this pest. She repositions her purse and closes her eyes. The little boy turns and grabs for his mother, who smiles at him lovingly.

3-26-13:

We made dinner—baked halibut, rice, salad—while listening to Bach playing loudly from radios in every room. O, so happy, eager to help out—chopping vegetables, preparing rice, advising whether I should use lemon or lime in the halibut, spontaneously coming over to hug me and have his back scratched—then sitting in his chair and reading from a fat file of the many forewords he's written over the years, holding his magnifying glass to his eye, reading aloud to me, stopping now and then just to savor the music.

"Wouldn't it be nice if there were a planet where the sound of rain falling is like Bach?" he says.

"Yes, Planet Bach," I respond.

He smiles—"Yes," he murmurs—picturing it, hearing it.

Later, lying on the couch, his legs over mine, we listen to
what seems an endless Bach piece. It goes on and on and
on, the pauses between passages "a majestic silence," as
O says. We keep thinking it will end, the announcer
interrupting to say what the piece is. Neither of us is sure.
But instead, the music continues. One begins to wonder
if it will ever end, life on Earth returning. O has his eyes
closed.

Finally, at 9 P.M. the piece comes to an end and we learn what
it was—"The Musical Offering," one of Bach's last works,
composed for Frederick II. He asks for the *Oxford Companion
to Music* to look it up, I hand it to him along with reading
glasses and a magnifying glass, and then he places a call to his
assistant and leaves a message on the machine:

"Hailey, I wonder if you can order a CD of this very
marvelous Bach piece that has been playing . . ."

I watch his face as he speaks. He looks so peaceful and
happy . . . *on a planet where the sound of rain falling is like
Bach . . .*

———————————

3-30-13:

It is hard to describe how tired I am. Noises hurt a little. I
crave the quiet—my kind of quiet: the sound of skateboarders
going uptown and taxicabs hitting the metal plate on Eighth.
Nothing else. Even the radio is too much.

———————————

4-30-13:

Random images and thoughts:

O, grumpily doing the dishes in the sink: "I wish the plates would somehow magically spring up and clean themselves . . ."

How, during a daylong series of panels and performances on O's work, he would repeatedly open his little tin and offer me a mint before taking one himself.

How, when we first met, he didn't really know how to (or didn't think to) share with another person. He'd never shared his life before, after all.

How, when I didn't feel well recently and took a long bath, he brought in to me a piece of toast with a slice of cheese on it. When I transferred to the bed, he brought me another slice.

How I could hear his feet shuffling on the carpet. And how I like that sound.

LESSONS FROM THE SMOKE SHOP

My thirty-year-long subscription to the *New Yorker* ran out—pure absentmindedness on my part—and since then I have been buying a copy each week at the smoke shop around the corner from our building.

It makes no sense financially. I could save seventy-three percent off the cover price if I renewed for just a year; even more for two. But I've found I enjoy the benefits that come with my $6.99 a week, beginning with Ali, the shop's manager.

Ali had formerly known me as a customer who occasionally came in late at night for a single vanilla Häagen-Dazs bar and asked for a book of matches.

The asking part is important. He once told me about a customer who reached over the counter and grabbed a book of matches from the box next to the cash register.

"'No, you don't do that,' I tell him," Ali recounted, still bristling. "'That is wrong. You don't go reaching across like that, without permission. You ask, I will give you a book of matches.'" He paused, looked at me. "Not everyone gets one."

Maybe they look like nothing special, Ali's matches. They're a generic white, and have "Thank You" printed on them.

I half-reached for one, just to mess with him. He held up a warning finger and tried to look stern, then selected a book of Thank You matches from the box as deliberately as if he were making a chess move.

"Here! Go, with your matches and your ice cream."

"Thank you, Ali. Thank you."

"You're welcome."

———————

HERE'S ANOTHER thing I've learned from hanging out in Ali's shop: There's no haggling here. This may seem obvious, but apparently it's not—not to everyone. I went in last Friday night to buy my *New Yorker* and, while browsing the magazines, saw a tall, imposingly built young man try to haggle with him over the price of a single cigarillo, single cigarillos and cigarettes being for sale here.

He fished in his pockets and spilled pennies on the counter. "C'mon, man!"

You might have thought he'd insulted Ali's grandmother. Ali sent that young man on his way.

"What, they think I'm going to bargain with them just because I have an accent?" he said to no one in particular, in his best indignant voice. Then he laughed. I did, too.

The store is called a smoke shop but, let's face it, it's a head shop: Hundreds of pipes and bongs line the shelves. There are rolling papers, booze, condoms, lube, pseudo-poppers, lotto tickets, junk food, you name it. It's so full of vices that, paradoxically, it's a vice-free

zone. I hardly ever indulged in potato chips before, but that's changed since I started buying my *New Yorkers* there. I threw in a bag of salt-and-vinegar ones this time—what the heck.

"Eight dollars," he said, "eight dollars, my friend."

I pulled the bills from my wallet while doing the math in my head. Suddenly it hit me: "It's always right on the dollar, isn't it? Eight, not $7.98. Or three dollars, not $2.95 with tax, or whatever?"

Ali smiled. "I round it off. Less change; it's good."

Ali kept the shop open during Hurricane Sandy, as unfazed by the storm as he is by the crazies he sometimes contends with on weekends. I went in on the second night of no power, lights, or water with Oliver. The shop counter was lit like an altar with a few well-placed candles; Ali looked like an oracle. In the semidarkness, one would never have known there's a ton of porn for sale in the back: gay, straight, and everything in between, and at every extreme.

We bought water and a flashlight and chatted for a while. He told us when to come back if we needed more—he had a bottled-water connection of some sort.

It felt nice to emerge from our dark, trapped apartments and connect with the formerly normal. We then stepped into the bar next door and had a warm beer by candlelight and toasted with fellow neighborhood drinkers, "To surviving Sandy and to being New Yorkers."

Even under normal circumstances, one would never find Ali in there—say, having a drink at the end of a night. In fact, Ali would never partake of almost anything for sale in the shop.

"I don't touch any of it," he has told me. "I don't do any of it. I drink Sprite. I go home to my family in Queens."

Even so, he doesn't seem to pass judgment on those who partake, or if he does, he's got quite a poker face. I think he gets that some of us may need a little something extra to distract us, to take the edge off, to gamble on the remote chance that we might win big in the lottery and get to leave this place.

I've lived in New York long enough to understand why some people hate it here: the crowds, the noise, the traffic, the expense, the rents; the messed-up sidewalks and pothole-pocked streets; the weather that brings hurricanes named after girls that break your heart and take away everything.

It requires a certain kind of unconditional love to love living here. But New York repays you in time in memorable encounters, at the very least. Just remember: Ask first, don't grab, be fair, say *please* and *thank you*, always say *thank you*—even if you don't get something back right away. You will.

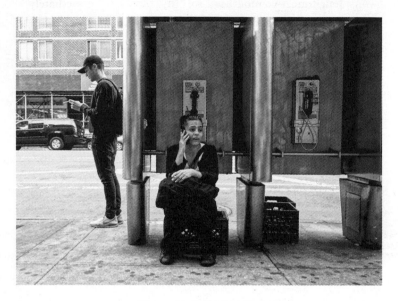

Woman Having a Bad Day

NOTES FROM A JOURNAL

6-2-13:

I visited Ali at the smoke shop this evening. I hadn't seen him in a long time, two months or so. "My friend," he immediately greeted me, with a smile.

I said I'd been away for a while and he immediately interjected, "So have I—one, two, three, four"—counting on his fingers—"twelve days, I go: Pakistan: back home. See my family: first time in long time: my wedding, the last time: nineteen years ago, it's been."

I told him that was absolutely wonderful. "Took your family? Your kids?"

"No, no, just me. I surprise my brother." He then went on to tell me in elaborate detail about how he had done it, arriving four days earlier than planned. He told me about each plane ride, how long each layover was, where he stayed, up until the final moment when he stepped out from behind a door and surprised his brother, "who almost fall down." His three other brothers and his sister were in on it. Ali smiled with great pleasure as he told me this story. As did I. I was touched: that he was talking about his siblings, not his parents, or his own wife and kids—about the special bond between siblings. I get that.

As Ali and I were talking, a tall and very built black man came into the store to buy lotto tickets. He overheard us as he was studying the lotto sheets. "That's nothing," he couldn't help commenting, "I'm one of fifteen kids. Fifteen!" Then he said, sort of under his breath, "My daddy couldn't help

himself, always out prowling, probably had lots more kids that I don't even know about—Haiti, you know."

Ali cut in: "That's the thing about third-world countries: There no TV, no movies, no video games—nothing to do—so people have babies."

The black man laughed: "That's right—only thing to do is fuck."

He got his lotto ticket and said so long. He held the door open for a tiny, bent-over old man, bent like an elbow at the lumbar spine. He leaned his cane against the counter. "You're back," he said to Ali, glancing up sideways.

"That's right," Ali said, "I came back just so I could take your money."

The bent man smiled.

Ali turned and reached for a pack of Marlboro reds.

———————————

Undated Note:

I see a young guy hustling mixtapes on Fourteenth Street—such a common sight; usually I walk right past but for some reason I stop tonight: "I'll take one." I pull a five-dollar bill from my wallet.

"I can give you change, sir," the young man offers, overly polite, "a ten for that twenty you got there."

I laugh. "You could, could you? How nice. No, five's what I can do." I hand him the bill, take the CD, and ask, "Can I take your picture?"

"My picture? All right."

I take his picture.

He hands me his CD and looks me in the eye. "Do you even want it?"

"No," I answer, "not really."

I give it back.

"Thank you, sir."

7-4-13:

An enchanted Fourth of July:

A lovely scene and vibe up on the rooftop to watch fireworks: lots of neighbors—old and young—and the cityscape behind us. Gorgeous sunset, the sky turning a mint green, the water, a silvery blue, and boats on the Hudson. A fresh breeze. Happiness in the air—one could feel it, and not just because O and I had gotten stoned in the apartment. Everyone felt it and commented on it—the beauty of the scene.

O held onto the railing and watched and talked as thoughts came into his head, describing in clear, precise detail, as if dictating a case history, the "superfluity" of images within his mind's eye—the one "gift" given to him in exchange for his impaired vision: how the triangular park appears to jut out from the roof railing; how he sees "flakes" of retinal snow when he looks at the sky; how his vision is cut off suddenly by his blind eye, and this looks like "a trapezius of irregularly shaped cardboard."

Soon, he was seeing hallucinations:

Letters and fragments of text superimposed on the greenish sky, newspapers with unreadable headlines, and more: "A hexagonal building, with a sort of delicate tracery at the lower edges; a gigantic version of me with an enormous phallus; patterns of colors in terra cotta and purple . . ."

He paused, soaking in these fantastical images, then declared with gusto: "The primary cortex! The genius of the primary cortex!"

Did neighbors hear? Probably so. I couldn't stop laughing at his ebullient cry.

And as I listened, happily, while also taking in the great beauty of my surroundings—"an attack of beauty," as O once said about a sunset—I thought two things: one, how there is so much in that head of his, so much O knows; and two, how different we are, in that what is going through my brain is not so much a stream of thoughts and images but of feelings and emotions. I am tuned into the people around me—the dynamics among the group of boys behind us, and the argument being had by the older couple right next to us, and my own complicated feelings. I may not know nearly as much as O knows, I am not as brilliant, but I feel a lot, so much, and some of this has rubbed off onto him and some of his knowledge has rubbed off onto me. We are like two dogs rubbing our scents onto one another.

———————

7-25-13—In Rhinebeck:

O: "I'm going to write a little piece about the book I never wrote, and then let's take a swim."

He sits at his desk with a yellow pad, takes up his fountain pen, and sets to work. I go into the main house.

Four hours later:

Pouring rain, no other sound but the hard rain, and then I hear the porch screened door slam, and footsteps: It is O, who walked from the cottage in his swimsuit, cane in one hand, umbrella in the other, a big smile on his face: "I finished my piece!"

I strip off my shorts and underwear and we walk, I naked, Oliver in his suit, through the pounding rain to the pool. We swim in the rain, the surface of the pool like a choppy sea.

"Nothing like it," I say.

"Yes! Lovely!" says O.

———————

8-1-13:

How vulnerable O seemed this morning, frail almost. I could feel it and see it from across the room. He said he woke with a thick head and a queasy feeling. He nuzzled his head into my belly. He asked if I'd run a bath.

———————

On Frailty

It is not incapacity

Not yet

Nor that one cannot do

As one needs to for oneself

But that thought enters every step taken

Lest the next one be the one

That takes one at last

Vigilance is one's best defense

Against debility's imminence

And what was once so simple

Getting out of a tub

Requires a higher mathematics

Advanced knowledge of biomechanics

To solve in advance

But it is also this

The knowingness of senses

So finely tuned to the sensuous

That nothing

Nothing

Is more beautiful

Than being in a bath

———————————

10-16-13:

I, soaking in the bath, O on the toilet, talking, talking about what he's been thinking and writing—short personal pieces, for a memoir perhaps. He had brought with him two pillows to sit on and a very large red apple. He opens his mouth wide and takes a gigantic bite. I watch him chewing for quite a while. After he finishes, "Bite me off a piece," I say. He does so, dislodges the apple from his mouth, and puts the piece in my mouth. We keep talking. I add more hot water. Every other bite, he gives to me.

There is a quiet moment and then, seemingly apropos of nothing, O says: "I am glad to be on planet Earth with you. It would be much lonelier otherwise."

I reach for his hand and hold it.

"I, too," I say.

12-9-13:

On a brief visit to San Francisco: How pretty and clean and uncrowded by comparison with New York—and how small—it seemed.

On Monday night I stopped by my old apartment (now occupied by a friend of a friend named Christian, though I still store things there), a place I had not visited in several years. I felt such a strange flush of sensations—familiarity mixed with forgotten-ness, if that's a word—something akin to déjà vu.

I tried keeping a conversation going with Christian while at the same time tiptoeing room to room, trying to remember what this place was, what it meant—the life Steve and I had lived here—and recognizing objects and furniture I had left behind in my haste to move to New York: *Oh, that was our table, our kitchen table. And that was our lamp—the lamp we bought at Ikea. And there, on the wall, that was my photograph.*

I said aloud, surprising myself: "I took that picture."

Christian nodded, as if he knew this better than I did.

"And this couch—*this* was mine too." I didn't mean to be reclaiming it. I was just recognizing it.

Christian opened the hall closet. All those books! Those were my books (are they mine still?) and those—all the sci-fi— were Steve's. Part of me just wanted to close the door, but I felt an obligation to keep looking. I went to the other closet next to the door; it was terrible, a jammed, chaotic mess of boxes and files. So much life, so many years, shoved in there, the door closed.

I went to the bedroom. It was tidy and quite empty except for a bed—again: "That was my bed" (is it mine still?). It was a nice bed, the bed I'd bought for myself about a year after he'd died, and for a moment I wanted it, wondered how I could get it to New York, and at the same time, amazed—really very amazed—that I had left it here, just left it. As if I'd committed a crime. As if I'd run for my life. I suppose I had.

I regretted it later (I shouldn't have said anything), but without thinking I found myself explaining to Christian how Steve had died—had died in that room. Christian was sweet,

gentle, kind-faced. He's Mormon. Very young. Blond and tall, handsome. When I had come in, he was drinking a glass of milk. He'll probably have nightmares now. He could not be more different from me, yet there he was, somehow inhabiting the life I had led. Was I his age when I moved in? I don't remember.

I looked at the full-length mirror on the hall closet door, where at night, after Steve died, I used to watch myself dancing, dancing in place for song after song after song, very stoned, the music loud so I didn't think any bad thoughts. I could feel it in my body still.

We went to the garage; Christian wanted to know what was mine and what wasn't, in case he wanted to get rid of things, make room for his own. There wasn't a lot there—a drafting table, an old wicker chair with the wicker broken through, shelving, a broken Xerox machine. It was all mine (was it mine still?).

I didn't hesitate. "You can get rid of it all."

I returned two days later when Christian was at work: I had to deal with some of my stuff before leaving. It felt not just sad but terrible, to be there alone, not only because of Steve's absence but also knowing that Jim and Vicki were not upstairs, nor Conrad downstairs, nor Robin and his wife down the hall, nor Jeffie or Elena on the third floor. Everyone had moved—or died.

I threw away books and left a box full in the lobby for neighbors to take. I threw out Steve's remaining clothes— clothes I couldn't part with at the end, clothes that reminded me so much of him—his boxers, his gym shorts, his flannel

shirt. But now? What would I do with them? I didn't want to imagine other people wearing them.

Reluctantly, I took down from the shelf a big brown grocery bag marked "Steve's urn and personal effects." I sat on the couch that used to be ours and went through the bag. Tears fell. I didn't clearly remember this, but after scattering his ashes I had turned the urn into a kind of time capsule, filled with personal items (Steve's hairbrush, watch, eyeglasses . . .).

Seeing Steve's photo over and over: driver's license, passport, family photos, snapshots—seeing how handsome he had been, and how he had changed, aged, how HIV and meds had changed his face—and thinking, "This used to be mine, he used to be mine" (is he still?).

It all seemed so delicate, fragile, like I might break these things with my thick, clumsy hands, even the photos— especially the photos. I felt half afraid, but also infused with tenderness. I opened a little plastic case that Steve used to keep in his gym bag. There, as if not a day had passed: his gym lock, some gum, his gym card. I remembered how he had worked out the night before he died. I didn't know what to do. Throw it all away? Keep it? I couldn't decide, so I didn't decide.

I packed the urn back up, placed it back in the paper bag, and returned it to the closet. I closed the door. I went to the kitchen and filled a tall glass with water. I drank it in one gulp. I placed it in the dishwasher and left. I called a taxi to take me to the airport.

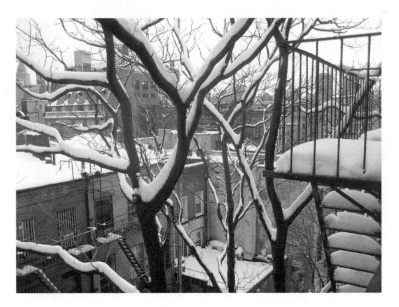

Trees in Winter

A YEAR IN TREES

Shortly after I returned from San Francisco, someone happened to ask me how I had managed to get over losing Steve, whom I'd loved so much and been with for so long. I gave a rather vague answer. What I had really wanted to say but found myself unable to explain (for it would have sounded too strange) was that I learned a good deal about moving through grief from some trees I once knew. They were not my trees. I didn't plant them. They stood right outside the windows in my first New York apartment. The only tending done was to give them my full attention over the course of four seasons.

When I moved in it was April, still cold, and the branches were bare. Facing northeast from the sixth floor, my view of Manhattan was unobstructed, seen through a latticework veil. There were five trees, each distinct. They were not beautiful. My next-door neighbor, a landscape designer, told me that the species, *Ailanthus altissima*, is an urban weed. But I never expected beauty. That they were tall and strong and present was enough. I found that *Ailanthus* derives from an Indonesian word meaning "tree of heaven."

I didn't cover the windows with shades or curtains. I would wake

with the sun and lie in bed and watch the tree limbs for a minute. Some mornings, the branches looked as if they were floating on wind drafts, as light as leaves. With a stormy sky, they turned black and spindly, like shot nerve endings.

Two years had passed since Steve's death, and though I had largely adjusted to his absence, I still experienced intense pangs of grief—*painful unpleasure*, in Freud's exquisite phrase. At times, I'd be tempted to take out old photos, just to look, just one picture, just for a minute, like a junkie on the verge of relapsing. But I resisted. I had seen the trees stand up to strong winds and hold their own against the elements.

By the end of May, buds had sprouted and turned to leaves. I lost my view completely but gained a lush green canopy. Along with the leaves came another development: rustling, in countless variations, soft, sharp, gentle, syncopated—like a quintet doing vocal exercises in anticipation of a command performance. Privy to melodies out of earshot to those on the street below, I tried transcribing the rustling but to no avail, the letters of the alphabet proving insufficient somehow.

The summer was a rainy one, perfect for watching Tree TV, as I came to call it. Once, during a ferocious thunderstorm I'd just managed to escape, I found the boughs being tossed about like rag dolls. The branches thrashed violently—whipping back and forth, slamming against the windows with a thud, then sliding down slowly before being lifted aloft again. I was riveted. The trees, clearly over-matched by the combination of winds, rain and lightning, were not fighting this storm but yielding to it.

This is just how they were built, how the species had evolved: to survive.

I am hardly the first to note that trees are at their loveliest when the leaves die. Correction: can be. My trees' leaves turned a sickly yellow and emitted an odor reminiscent of cat urine. In a way, having a new frame of reference was for the best. Steve had died on an October morning, and even if I were somehow to forget the actual date, I will always associate it with walking home from the hospital under a bright blue sky, the air crisp, trees lining the streets in their full glory: autumn, unmistakably. When it came time to scatter his ashes, my five sisters joined me at a forest preserve where the trees were ablaze in gold and russet. I buried his ashes at the base of a redwood.

With winter, the trees finally began shedding leaves. Background became foreground; my view returned. One morning as the sun rose, I caught the Chrysler Building casting its shadow on the MetLife building, a slim dusky finger drawn across the striated facade, as if tickling it awake. I felt I must be the only person on the entire island of Manhattan seeing this.

The trees took weeks to shed completely. Their limbs were covered till Christmas with what looked like dried corsages from a hundred high school proms. Birds came. Whether or not they were actually migrating, I don't know. I wanted to think so. They rested and preened, reminding me of myself finding refuge here.

That the trees were resilient no longer surprised me. Still, I marveled at how they took blows during the season's first serious snowstorm. The wind boomed like kettledrum rolls, the snow fell hard—hard—piling on limbs till they threatened to break. How is it that snowflakes, tinier than tears, can carry such weight? By midnight, Manhattan was gone. In its place, a peaceful new world, camouflaged as a cloud. Ailanthus, I would call it.

My lease-renewal letter arrived that February. I found a bigger, cheaper apartment on the East Side and made plans to vacate. I had a good cry the night before leaving; I would miss this place. When I woke the next day, I found the trees outside my bedroom window not moving at all, as if frozen solid in the night, an eerie reminder of my last image of my partner. I pushed the thought away. I threw back the bedcovers and put my hands to my stomach. I want to be as still as that tree, I said to myself, and stayed there until the feeling took: limbs not moving. Trunk barely rising with each breath. Neither yielding nor resisting. Just being still. Just being.

NOTES FROM A JOURNAL

1-6-14:

It is my birthday: fifty-three. The day started with a gift. Oliver sang Happy Birthday to me, joy in his voice (and amazingly in tune), and hugged me in the wonderful way he does, nuzzling his head into my shoulder and melting into me as I scratched his back.

He had a handwritten card for me, and, as is his tradition, a new element, Element 53, iodine, in a small bottle. He opened it carefully. "Take a whiff of that and it will clear your senses."

"In every meaning of the word, I hope," I said.

1-9-14:

O, while having a migraine, not bothered but fascinated by it, walking around the apartment: "I'm always surprised that the aura doesn't illuminate the whole room." (He once told me that the aura colors are as bright as flashing lights on a police car, which almost made me wish I could have one.) O looks at me, and smiles: "I'm sorry, but you are sort of covered in a Technicolor scotoma . . ."

2-1-14:

Dropping by O's at 4 P.M. to see if he wanted to go with me to the gym, and finding him curled up in bed, under the blue blanket, sweetly and peacefully sleeping. I waited several minutes, in case he might wake up. I cleared my throat a few times but he didn't stir. He looked so tranquil; I felt a huge rush of love and—I don't know why—sadness. I almost got choked up. I left him a note and went to the gym. Later, when I came out of my yoga class, I saw him on the second floor of the gym, and he looked so refreshed. He told me he'd slept for an hour. "Thank you for your sweet note," O said.

ON FATHER'S DAY

When I went to visit my father in Seattle, he didn't recognize
me. He thought I was a fellow soldier in his division.
I didn't mind. I was glad to think we were at Fort Benning and not
at the dementia care facility that's been his home for the past few
years.

"Lieutenant Hayes!" I said. "Nice to see you."

"Nice to see you too." He reached out his hand, and we shook.
Dad, ninety years old, was slumped in a wheelchair.

This visit was very last-minute. He had been hospitalized with
pneumonia and a small stroke. He was better now, my five sisters had
told me, but changed; he slept all the time, a deep silent sleep, even
though he is off all medications. Comfort care, they call this—a step
before hospice.

I had just arrived from New York. It was six o'clock, after dinner.
Staff had put residents into their pajamas and begun to get them
ready for sleep. Sophie, a bright-eyed ninety-seven-year-old, wore a
long silky nightgown with a high collar and long sleeves, as silvery
white as her hair. She looked like an angel you'd put on top of a
Christmas tree. Dad was in boxers and a T-shirt—he never did wear

pajamas—and a robe he's had for sixty years. It's made from a blanket he'd had at West Point—class of 1949—and covered with military badges.

He had slept through dinner, one of the aides told me. She warmed up some food and brought it to the table next to the TV area. It was a sloppy joe. He looked at it for a moment. "Split it with you?"

I was going to say that I was meeting my sisters later for dinner, but instead I said, "Sure," and I took a half. The hamburger bun was soft and warm. He ate his in three bites. He grimaced when I suggested he eat the vegetables, as if he were thinking, "Are you out of your mind?"

The staff scurried about, bringing nighttime meds and sleeping pills to each resident, the drugs tucked into a spoonful of ice cream. They were very gentle with them, and the residents responded gently and gratefully. One of the staff nurses stopped and spoke with Dad for a minute. She didn't have pills for him, but she gave us a carton of vanilla to share. "John and I have known each other a long time, haven't we, John?"

She was pretty, with strawberry-blonde hair and lots of eye makeup. Dad didn't respond but as she walked away he said, loudly enough so she could hear, "You called me by my first name." And then more to himself: "My reputation must be spreading."

He always had an eye for attractive women. He'd flirt with waitresses, cashiers, even nuns. I used to find this mortifying. On the other hand, I always had an eye for the guys. When I finally told my parents this news thirty years ago, Dad found it shocking, bewildering. I was his only son, for god's sake. There was a long time there, back when I was in my twenties and living in San Francisco, when

we didn't see each other or speak. We conducted a war of words via letters by mail. Eventually, we found neutral ground.

He doesn't remember any of that now—one of the blessings of dementia, I suppose. Instead, we talked about paratrooper training at Fort Benning and some of the jumps he'd made during the Korean War. Even after being blinded in one eye from a combat injury, he continued to make jumps—night jumps—into enemy territory. We also talked about swimming, something I've taken up with a great passion—Oliver and I swim together two or three times a week. I guess I'm more like my old man than I used to think. "You were on the swim team at West Point, weren't you?" I asked.

"Captain of the team," he said dully, then added, "I think."

As we talked, another resident wheeled up to the table where we were sitting. She sat there for a moment regarding us like weeds in a garden, and then asked, "Who's this?"

Dad didn't answer.

"I'm John's son," I said.

"You're my son?" Dad said. "You're not my son." Suddenly he looked confused and suspicious.

"Right. Yeah, we were in the infantry together," I told her, correcting myself.

He nodded and his head dropped and he fell asleep.

I rolled Dad over to the TV area, where one of the aides, Cassandra, was sitting with Sophie and others, desultorily watching "Jeopardy." Cassandra told me to roll John next to her. I did, but she grabbed the arm of his wheelchair and brought him even closer in. This woke him. She looked deep into his eyes, as if she were reaching some part of his brain deep, deep inside. "John?" she said. "How

many children do you have?" She spoke very clearly and calmly and smiled at him.

Dad thought for a moment. "Six? I have six?"

"Yes," Cassandra said, smiling, holding that gaze. "And how many boys and how many girls?"

"Four girls, two boys."

"How many, John?" She took his hand and gazed with such benevolence.

"Five girls, one boy."

Cassandra smiled. Dad smiled. "And what is your son's name?"

"William," Dad said, "William."

I put my arm on his shoulder and leaned over and kissed his head. He gave me a look like, "What the heck are you doing, kissing me?" He offered me his hand, and we shook—soldier to soldier. I said goodbye.

"See ya later," he said.

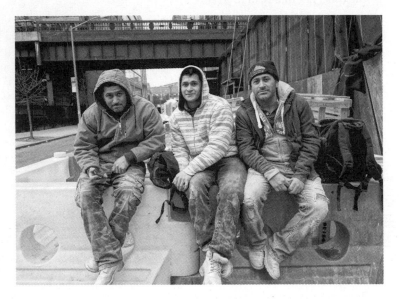

End of the Day

NOTES FROM A JOURNAL

3-2-14:

I lay on the couch reading the newspaper, not really aware of the time, not in a rush to do anything, as O practiced the piano. I put down the paper a few times and closed my eyes and just listened. I love hearing him play, hearing him hum along to himself deafly. He came over at one point and leaned over the couch in that way that he does, and touched me, in that way that he does, as if I were an animal in a zoo—his hand reaching through the bars to pet me (or is it the other way around—is he the animal, caged, pushing his snout through the bars, or his trunk or a paw, to feel me?).

"Come here, Beautiful," I finally said, grabbing O by the hand and pulling him toward me.

5-2-14:

The sun was setting, it was getting dark, when I popped my head in to Ali's this evening to say hello.

He held out his hand and we shook: "My friend," he said.

We stepped outside. We talked about the endless, noisy construction on Eighth Avenue: "Nine times I see it, they tear up this street," Ali said.

He told me that the owner of the smoke shop had bought the stationery supply store next door. Now he owns three shops on the block.

"The King of Eighth Avenue," I said, kiddingly.

Ali nodded.

"But you're still the mayor."

Ali pointed out shops across the street—three of them had
For Lease signs in their windows. The organic bakery had
just closed. "It was a good neighbor, they were here many
years." He paused. "Fifteen people lost their jobs, too, when
he had to close the shop—fifteen people who will have a hard
time getting another job." He pointed out that most of them
were students or undocumented workers. He shook his head.
"It's not right."

———————

6-3-14:

Sunday, O nuzzled his nose, dog-like, into the side of my
head, brushed it up and down and back and forth against my
buzz-cut hair ("It's like a meadow," he said) and then he did
so with the top of his head.

"Now, *why* does one do that?" O said, suddenly the scientist
in him coming out.

"Because it feels good," I answered instantly.

He laughed; it was such a simple and seemingly simplistic
answer.

"But that's very interesting," O said, picking up this thread.
"Does feeling good—does *feeling*—influence all of our choices
as animals? Something feels good, so we do it again—this is
how we learn about pleasure. Or it doesn't feel good, so we
learn that it carries a risk, a danger . . .? Are our lives ruled by
feeling?"

"Mine is," I responded.

He didn't seem to hear me.

"Do plants feel?" O said.

He looked at me like I held the answer, but continued on: "Certainly they do, but they cannot respond to feeling as quickly as we. Plants are rooted in the ground. They can move, yes, but not at the speed that an animal can. It may take years for a tree to grow, days for a flower to bloom. Is it *speed* then that differentiates us—this capacity for speed? You could do time-lapse photography of a vine crawling and see that it does, indeed, move, but one would have to speed it up a thousand times to match the speed with which an animal can react to threats or changes in the environment the way a human can."

O tilted his head, seemingly focusing on a corner of the room. "Yes, perhaps speed is at the essence . . ."

———————————

6-15-14:

O: "I like having a confusion of agency, your hand on top of mine, unsure where my body ends and yours begins . . ."

———————————

7-22-14:

I was standing in the kitchen last night making dinner for the two of us and a thought came to me: *This is the happiest I've ever been.*

I stopped myself: *Is that true?*

I kept doing what I was doing, making dinner, sort of testing the feeling; O was talking all the while; and I thought, *Yes, yes, it is true.*

PART III

HOW
NEW YORK
BREAKS
YOUR
HEART

Couple Under Glass

MY AFTERNOON
WITH ILONA

I rang the bell for Ilona's apartment at exactly three o'clock, the time we'd arranged for my visit, and she buzzed me in. "You're almost there," she called from up above the stairwell when I'd reached the second floor. Her building had no elevator. At ninety-five years old, Ilona goes up and down the three flights several times a day—"Keeps me young," she had told me.

Ilona had called me a couple of days earlier, saying she wanted to give me a gift—a thank you for the photographs I had taken of her and the prints I'd given her. "It will only take a half hour," she had said.

The door to her apartment was open just a crack, and she peeked out, her face like a bouquet of oranges, blues, and greens, a ribbon of red at the lips. "Come in, come in, make yourself at home." I squeezed through the narrow opening; the door was open just a crack because it could only open that far—stacks of things behind it prevented the door from opening fully.

Ilona had told me her place was very tiny—like herself (she stands

about four foot ten, and weighs no more than ninety pounds). She added, "Don't be surprised by anything you see," which sounded at once like a warning and an invitation.

Even so, I was taken aback: the room was tinier than I could have imagined—just one small room, with a half bathroom to the right; no kitchen; and a single window. There was a double bed raised high off the floor to the immediate left, just after the door. Stacks of things—books, magazines, boxes—towered. Opposite the bed was a small chair surrounded by more stacks—I can't even quite say what all these things were—creating a kind of island with just a narrow moat around it. The walls were lined floor to (almost) ceiling with more—boxes, books, clothes, and paintings—colorful canvases of landscapes and portraits. The wall opposite the door was mirrored, but the mirror was only visible at the very top, for it was covered up three fourths of the way.

By my description alone, one might think this tiny space was the home of a hoarder. But that would mean I am giving the wrong impression. Even though this small room was extraordinarily packed, there was no whiff of madness, of decrepitude. Things were colorful and soft (fabrics, clothes, hats). It smelled nice, clean. Everything was within reach; I supposed she needed nothing more. This was simply the home of a small person who had lived here for sixty-six years, and had sixty-six years' worth of things.

"I'm glad you could come," she said in a sweet, gracious way.

I was still dazzled, as if adjusting to bright sunlight after coming out of a tunnel. I thanked Ilona for having me and, with her permission, put my camera, bag, and jacket on her bed.

Ilona was dressed more casually than I'd seen her before when taking her picture in the park. She wore a brown caftan with some

sequins at the neck, a blue visor in her bright orange hair, and she was barefoot. She had her extraordinary eyelashes on, inch-long eyelashes she makes out of her own orange hair.

She quickly got down to business. I was here for a reason, not just a social visit: She told me she was going to make a drawing of me. "You took my picture, now I'm going to make a picture of you. Let's have you sit here"—she gestured toward a chair in the island right next to the bed—"the light will be better."

I smiled to myself; there was literally no other place I could have sat, except for on top of the bed.

I asked if I could help, but she insisted, No. I watched as this very small woman moved things from the chair so I could sit there, in the process creating a new stack. Her movements were slow and tremulous—Ilona has a sort of Parkinsonian tremor—but deliberate. "Here, try that."

I sat. Ilona frowned. "Too high. I'm very short, you know."

I chuckled and nodded.

I stood. She took more things off the chair—more books and magazines that had been stacked atop it. "Okay," Ilona said, "I think that should be good."

I sat down. She appraised me, narrowing her eyes. "Okay, we're almost ready," she said in her sweet, cheerful voice.

Ilona sat opposite me, our knees nearly touching. She had positioned a stool to the right and in front of her. I rested my left foot on the bottom rung. Ilona studied the crowded shelf to her left and, after some deliberation, chose three pencils and placed them atop the stool. From some other compartment, she selected a single, small sheet of thick paper, about four by six inches. She took up a small spiral-bound pad and placed the piece of paper on top.

"Okay, now get comfortable, just relax." I sat back a little bit.

"No, really relax. Shoulders down."

"Like this?"

"Yes, that will be fine. But you have to take off your glasses. Now, don't look out the window. You must look at me. I am drawing your eye."

"You're drawing my eye?"

"Yes, dear!" She said nothing more. My eye? Just one? I somehow imagined this meant something other than it did.

Ilona picked up a pencil, then studied my face for a long while. I stared into her eyes. Because of her tremor, her body moved slightly, her silver hoop earrings gently swaying. And then she looked down at the paper and began making some marks. She looked back up, staring seriously.

"You don't need to wear glasses to see well?" I asked.

"No, sometimes for reading at night I use some, but otherwise no. I had cataracts removed seven years ago, and since then, no."

"How long have you been drawing?" I asked.

Ilona looked up, put down her pencil, and gave me a patient smile then said quite firmly, "I can't talk while I work. We can talk later. You talk; I want to hear about you. At this moment, you are the most important person in the world."

I was a little startled and very moved by her words. Truth is, I had been feeling vaguely badly, badly about myself, for several days—a common condition for me. So, to find myself in a small chamber with a very small, very old artist just inches away from me, who was devoting a half hour, maybe more, of her limited time entirely to me—well, I was touched. *You are the most important person in the world*, I thought.

"Thank you," I whispered.

"You're welcome," she answered cheerfully. "Now, tell me about yourself."

So I did. I told Ilona about where I'd grown up, in a small town in Washington state, about moving to New York after my partner died, about my books and writing, and how I started taking pictures a few years ago. Sometimes she asked brief, simple questions with genuine curiosity ("What are the books about?" "Where does your family live now?" "How did Steve die?"), but mostly she just listened and worked on her drawing as I talked. I'm almost never a talker, usually.

I tried hard to stay very still and to gaze directly into Ilona's eyes, even as I spoke. She appreciated this. "You're a very good model," she told me at one point. "You don't move."

"Thank you," I said.

"You're welcome," Ilona replied. She was very courteous, but her manner remained serious.

I didn't have my glasses on, so I couldn't see well what she was doing, plus, she sometimes held the pad in one hand as she drew.

"Sometimes I squint my eyes," Ilona explained, "so I can get the general picture."

She made more marks. "Nature is so extraordinary—no two eyes are exactly the same," Ilona observed. She told me that she only does this—drawing someone's eye—for special friends. I broke the rule and asked her how long had she been making these drawings? "At least fifty years," she answered.

I nodded, but this was almost beyond my comprehension. She told me she'd drawn Tennessee Williams's eye once.

"You have very beautiful eyes; I didn't know, because of your glasses."

I listened and gazed at her.

She continued to draw as she spoke. "I see intelligence, and behind the eyes, a great probing."

I nodded slightly. This is a reading too, I began to understand.

Ilona worked in silence for a while. She squinted. "There is amusement in your eyes, but also . . . concentration, great concentration. Intensity, tremendous intensity—I've hardly ever seen anything like it."

Did she say the same thing to everyone who sat for her? I didn't care if she did.

I wondered if she'd say she saw sadness, loneliness, how I sometimes feel. But then again, at that moment, in that quiet chamber with the ninety-five-year-old artist, I didn't feel lonely. I felt like the most important person in the world. I told Ilona that my mother had been an artist, and she used to do sketches of my five sisters and me.

She looked up and smiled. "That's very nice."

"She was wonderful," I said dreamily, "I was lucky." I told her that the whole basement of our house was like an art studio.

She asked if my mother was still alive. I said no, and she nodded.

I told her that my father had been very different—a military man, a war vet, a drinker, a gambler, an Irishman, tough—but also a *provider*, a word not often used anymore. He went bankrupt twice, but . . . he provided for us, put us all through school. I was lucky there, too, I thought to myself.

I thought about asking Ilona if she had been married or had kids, but I stayed quiet. One day, I'd take another picture of her, and I would ask her to tell me about herself.

Every now and then, Ilona would put down her pencil and smudge a line with her finger, or take a small eraser and erase something. The pencils were all in shades of orange, lighter versions of the color of her hair and eyelashes.

"I'm almost done," Ilona said. I remembered how she'd told me on the phone that it would take twenty minutes, a half hour at most, and I noticed the green digital clock near her; indeed, about twenty minutes had passed.

She stopped, put down her pencils, looked at it carefully, smiled and nodded. "Here," Ilona said, "your eye," turning the drawing so I could see it.

I reached for my glasses and put them on. I felt speechless. Not only was it an accurate depiction of an eye, it was very clearly *my* eye—I recognized it—and although there was only one eye on the small piece of paper, it was as if the rest of my face were somehow there too: I could see my whole face in that one part of my body. I could see myself.

I admit, I was surprised. I hadn't known what to expect, I hadn't known if she could even draw; but indeed she could draw very well—and with delicacy, sensitivity.

Ilona could tell that I was pleased. She clapped her hands together. "Marvelous!" She turned the drawing back in her direction. "Isn't that the most beautiful eye!" she exclaimed. This wasn't meant as self-praise but instead as an appraisal of the eye itself.

I chuckled with embarrassment. "Thank you," I said, "what an amazing gift, I don't know what to say."

"You're welcome, thank you for the gift of your photographs. I'm happy we are becoming friends. Now," her tone changed, "I must spray it, so it doesn't smear." She handed me a can of varnish. "Can you shake that? You're much stronger than me."

By Ilona Royce Smithkin

I stood and began shaking the can, a familiar sound—the steel ball inside clattering—reminding me of all the cans of spray paint and varnish lined up on a shelf in the basement of my childhood home. I felt enormous standing next to her, not only hugely, comically muscular—like a wrestler in the ring on TV—but tall, which I'm not—I am only five foot seven.

"That's enough!" she cried above the racket—I'd gotten carried away, lost in my reverie—and I handed the can of varnish back to Ilona. She squeezed through the crack out into her hallway, sprayed the drawing, and returned. "It has to dry for a while. Now, shall we have something to drink? Coffee or vodka? Those are the only two things I know how to make."

"Vodka!" I said. "We must toast."

Ilona broke into a big smile. "Wonderful!" she said.

She made her way to the back right corner of the apartment, crouched down, and began rummaging. I gathered that this was the "kitchen area," though there was no stove, oven, or full-size refrigerator, only a toaster oven. "I'm going to choose a very special vodka," she said. "Cîroc, do you know it?"

"No," I said, "that sounds wonderful." I could see her pouring from what looked like a vodka bottle from an airplane.

Ilona brought over two very small blue glasses, about twice the size of a thimble, filled with vodka. We clinked glasses. "To a new friendship," Ilona said.

"Yes, to friendship," and we both took small sips.

Ilona at My Window

NOTES FROM A JOURNAL

9-4-14:

Today was the hottest day of the summer, hot and punishingly humid, as if the city needed to prove that it still had it in it. The heat makes people tense and cranky, but it also bonds—people talk about it in the elevator, in cabs, on the street—commiserate, reassure each other: *It'll pass; fall will be here soon.* But on the other hand, the sunsets on days like this are amazing, thanks to smog and heat, the color of the sky unclassifiable—almost a reminiscence, a recrudescence, of pink.

I decided to soak it all up, take a walk. I stopped at Ali's. "Hello, Sir," I said, imitating the way he says it to me. We shook hands. "How you doing?"

"Tired." He told me he hadn't had a single day off in a month—the boss is away—and he doesn't get one till next week.

That sounded brutal. "So, what will you do on your day off? Hang out at home . . .?"

Ali nodded. "Have the sleep, the eat . . ." He shrugged. "But you can't plan. Something might happen. The day off doesn't come, then what? Everything bad. You plan the day *on* the day," Ali said with real clarity, force. "Not before."

I told him that makes good sense: Take each day as it comes, don't overthink it.

"Yes, my friend, yes."

At the corner of Eighth and Jane, the light was red. I noticed a man on the bench in front of the Tavern on Jane. He held a piece of wood and a jackknife. I couldn't resist: "What are you doing?" I asked.

"Carving a piece of wood."

That was a great answer.

I rephrased: "What are you making?" I crouched next to him. The man was probably seventy-five or older, and thin and small. He wore a baseball cap.

"Oh, a letter opener, I suppose."

I just nodded, but I thought this was great for two reasons: because he was carving something slim and elegant out of a big hunk of wood (and he wasn't even close to finishing) but also because it was a letter opener he was making, a tool everyone once had—a necessity at one time; no longer so. O has several. But it goes without saying: You don't need a letter opener to open a text or e-mail.

I complimented him but the man seemed embarrassed. "It's just what I do. I'm a carver."

I told him good luck and said I looked forward to seeing his progress on it. "I'll be back another night."

"Okay, if I'm still around," he said.

————————————

A copy of Joan Didion's *A Book of Common Prayer* caught my eye in the window of Left Bank Books. Instantly, I felt myself to be sixteen again and in B. Dalton bookstore in Spokane and spotting that book in a display—*New Releases*—next to the cash register. I could still recite its opening page: "*I will be her witness . . .*" I had to go in. I love this shop because it stays open late. I love it because the clerks are never friendly. I love it because they sell old books, mostly first editions. I say old; most of them are from the sixties and seventies—my era.

Whenever I go in there, the clerk or owner eyes me, as he eyes everyone, as if it is an intrusion, as if I am interrupting him, as sometimes I have—he might be deep in conversation with someone. He might be reading. And sure enough, when I walked in the clerk glared at me from the back of the store.

"Are you still open?" I asked, even though I knew they had to be open since the door was open.

He nodded *yes*, but as if he were making an exception.

I tiptoed around and toward the back. He looked preoccupied, shelving books. "That looks like a nice copy of the Didion," I said.

He agreed.

I asked how much, and he said thirty-five dollars. I wanted to buy it, even though I already have a first edition of that book. I just wanted to have it; it looked so new, newer than mine. But I kept browsing. So many book covers I recognized: the huge Harry Abrams monograph on Edward Hopper (I had that once; what happened to it?), and there, on the poetry shelf, face out, in a protective plastic cover, *Ariel*.

Ariel: Oh, *Ariel*. I felt something very deep, sadness, bittersweetness, a recognition, almost like tears were going to come into my eyes. I don't know how else to describe it. It was exactly the feeling I have when I see Steve in a dream. Loss: but loss of what? Youth? Poetry?

Five or six books suddenly fell on the shelf where the clerk was rearranging things. In that silent bookstore, the sound was loud and instantly recognizable, the sound of books on a shelf losing their balance, falling on their sides, the weight of a book as an object. It was a good sound, a familiar sound, comforting, and I thought, that sound is reason alone to have books. May books never disappear.

I took the copy of *Ariel* and read a few pages. "*Daddy, Daddy . . .*" I smiled. The force of the poetry was unchanged. The sadness melted into something like gratitude as I looked at the poem titles, poems I once knew well. *Consciousness that I am thankful,* I thought to myself.

———

9-13-14:

I woke at 4 A.M. to screams—not screams, yelling—and horns honking. In the moment, I almost thought I was having a nightmare, triggered by a violent movie I'd watched. But it was too real, outside my window, eleven stories below. I lay in bed and listened: chaos, one could feel and sense it, even without seeing what was going on; it sounded like a crowd. I finally got out of bed and looked out the window. It was at the gas station: a line of cars, five or six at the pumps, and there appeared to be three or four people centrally involved in an

argument. One of the gas station attendants, in a uniform, and a young man—the two of them yelling at each other, threatening one another with fists and punches thrown in the air. A young woman circled around, and she was going at the attendant just as viciously, attacking him physically, yelling, cursing. Others would congregate, try to break things up, and then back out. The fight moved back and forth across the grounds of the gas station. It would almost quiet for a moment, as if the fighters were retreating, and then start up again. At some point, the woman got thrown onto the ground; at another point, someone else did.

It was awful to watch. From afar, they looked like animals, could be mistaken for animals, had it not been for their human voices, their cursing—terrible words.

How New York breaks your heart, I thought to myself. This is one way: with violence, with hatred, rage.

Too much to drink, too: alcohol at 4 in the morning.

I turned on my air conditioner to drown out the noise and took half a Xanax to go back to sleep.

Policeman on West Fourth Street

HIS NAME IS RAHEEM

"It's Arabic," he told me. Sometime yesterday morning, Raheem had parked his caravan of three separate shopping carts, each piled six feet high with near-bursting bags of collected cans and bottles, on Eighth Avenue, across the street from where Oliver and I live. You couldn't miss it, really—there was audacity in his taking over the bus lane as if it were his private parking spot—and yet, people streamed by without glancing in his direction. Or maybe he wasn't really there. In the extreme heat and humidity of the day—temperatures over ninety—one might almost think Raheem was a mirage.

I was on my way to a doctor's appointment uptown when I first saw him, asleep on a milk crate, his bags shading him from the sun. I could see the photo in my mind even before I was close enough to take it. I thumbed my camera on and pocketed the lens cap as I raced toward him. I crouched down directly across from him, found his face in the frame, and snapped: 1, 2, 3, 4. I felt like a poacher. I *was* a poacher: The sleeping man roused, and cried out angrily, "Get the fuck away from me!"

I felt terrible, ashamed. I never do that—never take pictures of people without asking them. It was wrong, and I apologized to the

man, who looked like he was silently laying a curse on me. Nevertheless, when I got on the subway I looked at the pictures I'd taken, and I saw that they were good, that they captured something real. But then, I'm sure poachers say that about the tusks they steal, too. Still, I didn't delete the pictures.

Returning home later in the afternoon, I saw him still there from a block away. I bought a bottle of water, approached, and gave it to the man. He had hundreds, maybe thousands of empty water bottles, but did he have a full one?

"You getting enough water today?" I asked. I don't know if he remembered or recognized me, but he accepted the water with thanks. Maybe he would just empty it and add it to his collection; I didn't know.

I asked him what he was up to. He told me that he was on his way, eventually, to Duane Reade, the drugstore, where he would turn in his bags and get money in return. He told me there isn't a Recycling Center in Manhattan, as there is in the Bronx, and the drugstores won't take everything at once, so you have to go to one after the other after the other. Moving this caravan from one drugstore to the next would take hours, days maybe. The shopping carts weren't linked— he couldn't tow them all at once; instead, he would have to move one cart a time, while eyeing the other two, to make sure another can collector (the junkie ones, he said) didn't steal them. But he explained this matter-of-factly, as if, *This is just what one has to do.* Now, he was taking a rest from the heat.

"Do you have something to eat? A place to sleep tonight?"

He nodded, again very matter-of-fact; he wasn't worried about that. This was when I asked his name and he told me it was Raheem. I later learned that it means "merciful."

I said my name is Billy. I told him I'd like to give him something to help him out. He had not asked me for a dime, after all. I didn't want to offend him again. "Is that cool?"

Raheem nodded. I gave him $20.

"Peace and love, and hallelujah," he said quietly, sincerely, like a prayer, "blessings to you." When I asked, he said it was okay if I took his picture now, and I took a few more.

I asked him how long he'd been on the streets and he told me sixteen years. Anyway, finding food and a place to sleep weren't a problem—that's the least of it, he implied. The problem is the police, who harass him, tell him to get his junk out of the street, or even worse, he said, "These people here now with $120 million apartments—they say, 'Get away from my building! Why don't you just throw all that shit in the garbage? I'm gonna call the cops!' And they do! Fuckers. And then I have to deal with the cops again."

He murmured, "The Village was a lot friendlier when it was entirely gay."

This made me chuckle, and I said I'll bet it was, I wish I'd lived here then.

"They think I don't know the law. I know the law. I know my rights. I'm not doing anything illegal. I'm not a junkie. I have every right to do this," he said. He looked over at the bags and bags of what most of us would call garbage. "This is my work!" he said with real feeling. "My work!"

In that moment, I suddenly saw every person on the streets of New York who collected bottles and cans from garbage bins and turned-over trash cans differently—all the elderly tiny Asian women, sometimes whole families, Peruvian, African, some with bags balanced on poles carried on their shoulders: They were making

work for themselves, performing a job most of us were too lazy or busy or wealthy to even think about.

But Raheem wasn't finished speaking. "I say to those guys, the ones who own the buildings, 'What are YOU doing? I'm saving the Earth! What are you doing for this planet?'"

NOTES FROM A JOURNAL

9-14-14:

O heard from one of the doormen that the smoke shop down the block from Ali's was robbed last week. Thugs came in late on a Sunday night just when they were closing. This made me worried for Ali, so O and I went in to ask him about it.

"There's a sign on the door," he said, pointing to a "Wanted" poster—a grainy image taken from surveillance video. "They have guns, use a Taser, tie him up, take all the money, cigarettes, lotto tickets—"

"Is he okay now?"

Ali shrugged. "He okay."

He seemed distracted, expressionless, listless almost. Maybe he was just tired of telling the story. Maybe he's sick of people like me being surprised—don't we know what a dangerous position they're in, working alone in a shop that sells cigarettes, liquor, lottery tickets? How naïve can you be?

O and I bought a newspaper and one ice cream bar. "Nine dollar," Ali said, "nine dollar." He looked at Oliver: "And some matches? Some matches too, Doctor?"

O nodded.

Ali threw in two books.

I noticed they were blank—just white covers. "The matches," I said, "they don't have 'Thank You' printed on them anymore?"

Ali still had that frozen expression on his face. "No one says thank you, so the matches are same."

"Really . . .?"

"Things change," Ali said with not a hint of regret or emotion. "Things change."

9-20-14:

"Do you sometimes catch yourself thinking?" says O, out of the blue, in the car, on the way to his weekend home in the Hudson Valley. "I sometimes sort of feel like I'm . . . looking at the neural basis of consciousness . . ."

"Yeah?"

"Those are special occasions," he went on, "when the mind takes off—and you can watch it. It's largely autonomous, but autonomous on *your* behalf—in regard to problems, questions, and so on." A pause, then returning to his thought: "These are *creative* flights . . . *Flights*: That is a nice word."

"Mmm, I love that word . . . What . . . triggers such flights for you?"

"Surprise, astonishment, wonder . . ."

"Yes."

9-25-14:

Heading home after taking pictures in Washington Square Park, I took a shortcut through the alley off Waverly where I saw a guy on the other side of the street walking with a jangly rhythm—music in his body. "How many times have I seen you today?" he yelled in a friendly voice. "Twenty-five? Thirty? And now? Again . . .! Unbelievable."

I couldn't see very well—it was getting dark—had I seen him before? Possible. After all, I had just taken photos of a teenage couple making out on a bench that I'd photographed three weeks earlier in a different park. The city can seem so small.

I played along: "Thirty? No, not thirty times—seventeen, I think."

"At least that, I think you lost count," said the young man.

I crossed the street and came to him. He was scrappy, thin, young—maybe twenty-three, twenty-four—wearing a baseball cap low over his face, almost covering but unable to conceal his alert, flashing eyes. He was high or drunk. He had a handsome face. He said his name was Billy. I asked if I could take his picture.

"What kind of photography do you do?"

I told him.

"Show me, show me some."

I reached for my phone. He objected—vociferously: "Not your phone! Not your fucking phone!" Then, quieter, whispering almost: "On your camera. Show me on your camera. Show me the last picture you took."

"Okay, hold on." I pressed the review button and found it: the picture of the young lovers on a park bench. He grabbed my hand and pulled the camera closer to his face; he studied the picture carefully—a young man and woman, in love, caught in a carefree moment; and I wondered what went through his head. Did he see himself in them or complete strangers?

"Show me more," Billy said. So I did. He nodded, approving.

He stood in the middle of the street. "How about here? If we're going to do a picture, it's gotta be the best."

"Yes, absolutely."

"It's gotta be better than anything you've ever taken."

I was just about to click when, suddenly, he dashed across the street and down into a stairwell leading to a basement. I walked over, peered down at him.

"Billy, do you know what it's like"—he pulled out a baggie and a lighter—"to smoke?"

I knew he meant crack. I shook my head.

"It's unlike anything else, it's like heaven, it's—when I smoke, I want to do anything, I can do anything. I could take off all my clothes and dive into a garbage can and it would feel good."

I watched as he took out a joint. I put my camera to my eye and began taking pictures. Billy lit the stump of a joint laced with crack. He held the smoke in and finally released it. He watched the bluish smoke float away.

He fell back, eyes closed. "I want you to take a picture of that—of the smoke."

Billy in the Alley

I took up my camera again, he relit the joint, and I took more pictures.

I thought to myself, He's going to die this way.

———————

10-24-14—In Amsterdam:

On a short holiday in Amsterdam, one of O's favorite places; my first time here.

Last night, he was having dinner with a colleague and encouraged me to go off on my own, have an adventure. So I did.

Not sure where to begin. I suppose I could start with the taxi drive to the restaurant, or with the meal itself—the lovely food, the lovely waitresses. Or I could start where I ended up, in a dark bar, until 4 A.M. Or perhaps on my walk back to the hotel, with a detour through the red light district. But I will get to all that on another day. For now, I have a short New York story—but one set in Amsterdam.

After eating, I sat by a canal and took tokes from the joint I had gotten at a "green café" yesterday. I got gloriously high, then I headed into the bar across the street from the restaurant, the bar that the waitresses had said is "the best" in Amsterdam. It was packed, uncomfortably packed—but with gorgeously dressed, gorgeous young Dutch people. I managed to find a spot at a table on the side where I fell into conversation with two outstandingly pretty young women. We talked for a while. I showed them a bunch of my pictures on my phone. But honestly, it wasn't very long into our conversation when one of the two, Pauline, who had long

blonde hair piled atop her head, suddenly said to me, apropos of nothing that I recall, "I am going to write you a poem."

"Really?"

By her expression, it was almost as if I'd offended her by asking if she'd really meant it. "Of course!" she insisted.

I told Pauline that this had happened to me before—actually, twice before, on the street, in New York. She didn't look impressed—or surprised, for that matter.

She found a pen in her purse and retreated to the corner. The other woman and I talked while Pauline wrote. Sometimes I looked over at her and she would stare back at me with great concentration, almost viciousness, more like an animal hunting than like someone writing something. Finally, perhaps twenty minutes later, she rejoined our little table, and presented to me my poem, written on the back of a flyer, and over the din in the bar, and the round of drinks I had just bought, she read it to me:

the choice

you made,

just to accept

that you don't

know

though you

read, think, talk

is the best

decision you

ever made

because since

then

you enjoyed

people

life

a drink

kind of

you learned

to love life.

Pauline

11-2-14:

Back home: I dropped by Ali's at about 9:00 on my way to grab something to eat. I almost didn't go in; he had four or five customers in the store. We said our hellos—"Hello, *Sir*"—and I told him I'd head back and look at the magazines. As I stood back there, I overheard a young sort of hippie couple ask Ali a few questions about lotto tickets and then, to my surprise (because they didn't look like they had a lot of money), ask Ali for $100 worth. He made the sale. They left. The store was still crowded when a young man wandered in, looked around a bit, and said to Ali, "What do you *sell* here?"

"What do you mean what do I sell? What does it look like I sell?"

The young man looked back at him as if waiting for a different answer. Then he turned and quickly ducked out the door. I put down my magazine and walked toward the counter. "That was weird," I said, "do you get that often?"

"What don't I get?" Ali said.

The store was cleared out now but for one guy buying lotto tickets. On seeing me standing near him, Ali said right away, "This is the guy—the *newspaper* story. This is the guy I told you about."

"You're the one who wrote the story about Ali for the *Times*?" the other man said.

"I am. Did you see it?" I put out my hand and we shook.

"Of course I saw it," he answered, "this guy was so excited about it—" he pointed to Ali, who was beaming, but then he added sarcastically, "You were way too kind."

I asked what he meant.

"He's not nearly that nice to everyone—definitely not to me, and I've been coming here six or seven years." He had a smile on his face as he spoke, and I could tell he was poking fun, but he meant what he saying, too. The man was a little older than me, maybe late-fifties, tough-looking. "We've had some big arguments, Ali and I," he said, "believe me, you were way too kind."

"Arguments about what? What are you talking about?"

He rolled his eyes. "You name it: religion, politics. I'm not going to say any more—it might end up in the *Times*, right?"

Ali laughed at this. "That's right—in the next article. Be careful what you say."

I felt uncomfortable and wanted to change the topic. I asked him about lotto tickets—if he buys them every day, and so on. The man was holding a wad of cash. He looked defensive. "Yeah, every day." Again he said that thing about not wanting to say more—it might end up in the *Times*. He and Ali picked up the thread of this topic and talked back and forth. Meanwhile, I pulled my camera out of my pocket; I don't know what came over me. Suddenly I had this idea that I wanted a picture of Ali. "Ali? Can I . . .? Can I take your picture?" I said in a pause in the conversation.

"No," he said sincerely, with a wave of a finger.

"He won't let you take his picture," the other man said, "I've tried, I'm a photographer." He looked at me. "It's a Muslim thing."

Ali immediately took umbrage. "It's not a Muslim thing! I tell you that. You don't listen. I never say 'It's a Muslim thing.' That's not right."

"What are you talking about? Just the other day, when I tried to take a picture in here, you said, 'No, Muslims can't do that.'"

"No, I don't say that. I say, 'It's against Islam.' All of Islam: Someone take a picture of you, it's not right—it's lifeless—like a sculpture, it's lifeless."

Words were coming fast but it was as if I pressed pause on Ali's words: *It's lifeless; a photo is lifeless.* I looked him in the eye, and nodded respectfully. All the while, the other man was yammering on. I cut in at one point and tried to lighten the

mood. I told Ali that was fine, I absolutely understood, and that I always ask people first if I can take their picture. I found my Instagram page on my phone and handed my phone to Ali to take a look. He squinted his eyes just a bit, and began scrolling through the pictures. He stopped now and then, nodded. "Good, very good," he muttered.

The other man began asking me some questions, I don't remember about what, and out of the corner of my eye I noticed Ali holding the phone up and clicking something. "Here you go," he handed the phone back to me.

He took a picture of me, I thought, *Oh great, the last thing I want*. I hit the screen to open the camera on the phone, and a tiny thumbnail photo appeared in the bottom left. It wasn't me he had taken a photo of; it was himself; he had pushed the button that turns the viewfinder around and taken a picture of himself. I looked up and nodded at Ali. He smiled in return; clearly, it had been intentional. I thought of saying something, thanking him, but instantly knew better. The other guy would make a big deal of it. So I slipped the phone into my pocket, shook Ali's hand—"Good night, Sir!"— shook the other fellow's hand, and went on my way.

Much later that night, 11:30 or so, I went back into the store. "Ali, thank you—thank you for the photo."

He smiled but he was serious. "I never do that. I've never done that for anyone but you. It's what I say, in Islam, no—no photos, except in your own family. Only family photos."

"I understand. Thank you again, my brother," I said.

We shook hands, and I went home.

A MONET OF ONE'S OWN

I slipped away from work one Monday to take my two nieces to the Metropolitan Museum of Art. We went to the Garry Winogrand photography show. I doubt there's a better way to play hooky in New York.

I almost wished I'd brought a thesaurus, because it wasn't long before we found words failing us. An image of an acrobat caught midleap on a Manhattan street, for instance, struck the three of us as the epitome of "amazing." So did another photo. Then another. Upon seeing the first few dozen of the more than 175 prints on view we pledged that we would not use that word to describe every single photo. Beautiful, incredible, joyful, strange, very sad—we made it as far as the second room before we were back to the A's.

"It is just so . . . amazing," said Katy, who's eighteen and an aspiring photographer, as if she'd been rendered helpless by yet another example of the Bronx-born artist's particular genius for street photography. I nodded in sympathy. In a world plagued by intractable problems—police shootings, Ebola spreading, spiraling civil wars, planes falling from the sky—lacking sufficient synonyms for a work of art seemed a good one to have.

When we reached the last room, I asked Katy which picture was her favorite. She led me back to the one that had stumped her in the synonym department. Her sister, Emily, who's fourteen and had been off wandering through the Met's collection of European paintings, then showed me her favorite piece in the museum: a Monet water lily (the first she'd ever seen) from 1919.

This is when I let each girl in on a secret: It can be yours. No different from falling in love with a song, one may fall in love with a work of art and claim it as one's own. Ownership does not come free. One must spend time with it; visit at different times of the day or evening; and bring to it one's full attention. The investment will be repaid as one discovers something new with each viewing—say, a detail in the background, a person nearly cropped from the picture frame, or a tiny patch of canvas left unpainted, deliberately so, one may assume, as if to remind you not to take all the painted parts for granted.

This is true not just for New Yorkers but for anyone anywhere with art to be visited—art being a relative term, in my definition. Your Monet may, in fact, be an unpolished gemstone or mineral element. Natural history museums are filled with beauties fairly begging to be adopted. Stay alert. Next time a tattered Egyptian mummy speaks to you across the ages, don't walk away. Stay awhile. Spend some time with it. Give it a proper name: Yours.

But don't be hasty. You must be sure you are besotted. When it happens, you will know. A couple of years back, I spent much of Memorial Day at the Museum of Modern Art with Oliver, a self-described philistine when it comes to art. He struggled to see the value in the work of the performance artist Marina Abramović as she sat gazing into the eyes of museum visitors. And the enormous,

bright red Barnett Newman painting, *Vir Heroicus Sublimis*, got him all worked up, railing against the pretensions of abstract expressionism.

This was my cue to lead Oliver to another gallery on another floor and steer him toward an early, rose-tinted Picasso. He smiled a smile that even Edvard Munch might have wanted to paint. And he stayed and stayed and stayed, a self-appointed sentinel to Picasso's *Boy Leading a Horse*.

"It's yours," I said. "Congratulations."

I have been slowly adding to my own collection since moving to New York. I acquired a Francis Bacon nude that I fell hard for at the artist's retrospective at the Met several years ago. The piece was on loan from a European museum, and the fact that I might never see it again made it all the more irresistible. My naked Bacon and I are forever embroiled in a long-distance romance.

Usually, I gravitate toward works that are overlooked, tucked back in a far corner, or that are a museum's "John Doe"—Artist Unknown. I am just as likely to make a medieval suit of armor mine as I am an obscure Diane Arbus. I also push myself to go into galleries that I would not normally think about entering. Often, this is a source of my best finds. I am strongly anti-museum-map and militantly in favor of getting lost. While there's nothing wrong with navigating straight to the old masters, I believe it's far nicer to lose your way in a labyrinth of galleries and suddenly find yourself, as I did one Saturday evening, face-to-face with an Odilon Redon bouquet looking so fresh I could have sworn the paint was still wet.

Perhaps the best part about possessing art in this way is that what's mine can be yours, and vice versa. In fact, I would not be surprised if

half of New York City has also put dibs on the Monet that Emily chose. This made it no less hers.

I brought her in closer to her new acquisition: "Emily, meet your Monet. Monet, Emily."

Words did not fail her: "Hello, beautiful," she whispered.

Teatime

NOTES FROM A JOURNAL

12-1-14:

> After nearly five months in the clock repair shop around the corner, O's beloved grandfather clock (his mother's) is finally back home, in one piece, and working again for the first time in seven or eight years. Working pretty well, that is, not perfectly.

> At one point last night, the clock chimed, startling us (we're not used to it). O and I counted the chimes carefully. A big smile broke out on his face. "Oh! That's very eccentric! Earlier, it did ten chimes at four o'clock, and now, seven at nine."

> We laughed how this is like having an aging parent in the house, one who's a little "dotty," gets a little lost, misremembers, from time to time . . .

12-21-14:

> Sunday, a very cold, gray Sunday:

> O and I got bundled up and walked—walked down Fourth Street to Christopher, walked slowly, carefully, minding the ice and the cracks in the sidewalks and the curbs. O was in a good mood. He has completed the final edits on his book, his memoir; it has been sent to Knopf; and I think he feels a great weight lifted. In this book, he discusses his sexuality and private life, including our relationship, for the first time ever. He's done it! The proof is sitting on his table: a manuscript at least six inches high—*My Own Life*, he

wants to call it. "It accounts for your whole life," I said spontaneously.

"It is *an* accounting of part of my life," Oliver corrected more carefully, laying stress on the *an*, "not without some omissions but all in all the truth."

We were walking down Fourth Street to McNulty's to get coffee, a stroll we've taken many times, in many different kinds of weather, and light . . .

"Look at that tree!" I said, stopping, and putting a hand to his back to make sure he felt steady as he looked up.

"Oh yes, that's a marvelous one," he whispered. The tree was enormous, tall, and gnarly, limbs growing in all different directions—west, east, up, down. Part of the tree was covered in ivy, and the bottom half of the trunk was circled in Christmas lights.

"There are a lot of things growing there," I said.

"Indeed," O said.

We kept walking. He talked; I listened. In the apartment, he'd nonchalantly said something arresting: "I find I am more interested in the positive pathologies—"

"The 'positive pathologies'? What's that?"

"Things like the zigzagging of migraine auras, tics, spasms, seizures—excesses, hypertrophies of physiology, not losses, absences."

I understood; it made sense—he who has lived a hypertrophied life. He talked about this more as we walked. I felt this was material for an essay, another for his collection on

the "neurophysiology of everyday life" he's been thinking about. But all of this serious talk did not keep us from enjoying the sights. We saw lots of nice lights and decorations. ("Those are jolly," said O, seeing greens and lights on an iron rod fence.) A small tree in a yard was decorated with round glass bulbs. Wreaths bedecked doorways.

We felt happy living in the Village.

We remembered memorable walks: "Do you remember that little boy? That little Indian boy," I said, "the one I took pictures of?"

"Oh yes, he was not only amazingly photogenic, but had a whole repertoire of poses. Do you suppose he was born that way?"

I laughed—O, who knows nothing about Facebook or Instagram. "No, I think that was a definite case of nurture over nature."

We found a broad, dry sidewalk, empty of people, so much so that O felt comfortable letting go of my arm and walking on his own. He took my arm again at Bleecker. I steered him to the left.

"Now, now, this looks familiar, but I have no idea where we are," O said. (How many times have I heard that—O and his topographical agnosia, the geographic equivalent to his prosopagnosia.) It occurred to me that now I probably knew the Village better than he did, which is saying something since I've only been here five years. But I've walked a lot. I may not know the names of the streets, but I know how to get from here to there. And I recognize everyone.

We took a right onto Christopher. Soon we were pushing open the door to McNulty's, one of my favorite places in the world. I still remember when he introduced me to McNulty's. It was wonderfully warm inside, and crowded (the crowd helping to heat the place). As we waited, a tall woman said to Oliver, "I like your cane!"

He thanked her and held it up for her to admire the handle, which was completely "enrobed" (O's word) in different colored rubber bands.

"How long did it take you to collect all those?" she asked.

"About ten minutes," he said.

"I did not expect you to say that!" she said, laughing.

"I have a vast collection," he said with modest pride.

O demonstrated how the rubber bands keep the cane from falling when propped against something: "A physical therapist taught me that!"

We bought three pounds of coffee—as well as a box of tea sacks, two tea bricks, which he'll give as gifts to Jonathan and to Nick's family, and some coffee-flavored candies—O is going to his nephew's in D.C. for Christmas. It came to $125—not a small amount of money to spend in a coffee shop. O is not an extravagant man, by any means, except for on those rare instances when he is.

We said happy holidays and thank you to all the gentlemen at McNulty's. We walked up Hudson, like other streets empty of people because of the bitter cold. O talked easily and nonstop, making his signature "pronouncements," as I think of them.

For instance: suddenly saying, "I find I am very interested in automatism."

I elbowed him: "Only Oliver Sacks would say that!" He started laughing. "Well, why not? It's very interesting. It's the signal characteristic of homeostasis!"

12-25-14:

Spoke to O, who is in D.C.—"Merry Christmas," and so on—he sounded tired and said he was not feeling well. Back home tomorrow. Hope he's okay. We leave for a trip in ten days.

1-12-15:

Got back last night from St. Croix—a birthday trip. I turned fifty-four (equivalent to the atomic number for xenon, so O gave me four xenon flashlights). It was warm there, sunny, I did some scuba diving and we swam every day, which was nice, yet I'm relieved to be home. O did not feel well much of the time—nauseated, tired, slept a lot. We almost cancelled the trip last minute. Two nights before we left, he told me had "dark urine." I was skeptical—he's hypochondriacal even on good days, as he is the first to admit. But I could see he was worried, talked him into peeing into a clear glass so I could check, and was startled when he brought it into the kitchen; his urine was the color of Coca-Cola. It seemed to clear up some while we were in St. Croix. Even so, he had made a doctor's appointment before leaving for the trip.

Later:

O just returned from his GP, who thinks he has some kind of gallbladder inflammation, maybe gallstones. Did an ultrasound, but they're running more tests.

———————————

1-15-15:

O's doctor phoned: "peculiar findings," re: CAT scan yesterday. So: Am taking him to see a radiologist at Sloan-Kettering. They want to see him this afternoon.

BUT . . .

Sloan-Kettering is a cancer hospital, but cancer had not entered my mind. I was still banking on the possibility of gallstones; I thought, at worst, Oliver might have to have his gallbladder removed. I remember the doctor entering the consulting room with a young medical fellow (he was from Italy, I think), and how nervous the young man looked. The doctor got right to it and told us that he had carefully reviewed the CAT scan and, although a confirmatory biopsy would have to be performed, he was ninety percent sure of the diagnosis and said he had some "tough" news. I remember that word, "tough." He asked Oliver if he'd like to see the CAT scan. Oliver said yes, of course, and he flipped on the computer monitor. I got up and stood behind Oliver, who scooted his chair in close so he could see.

Later he told me that he knew instantly what the scan said. I did not, and I was stunned when the radiologist explained that what we were looking at was a recurrence of the uveal melanoma Oliver had had nine years earlier—a cancer arising from the pigment cells in his right eye; over time, it had metastasized to his liver, which was now "riddled like Swiss cheese" with tumors. He enlarged the image on the monitor, so the white spots—the tumors—looked as large as

those made by a hole punch. In cases like this, with a possibility of the cancer spreading, and at Oliver's age, the doctor said, neither a liver resection nor a liver transplant would be possible.

A liver transplant? I thought.

What has stuck with me so clearly is how calmly Oliver took this news. It was as if he was expecting it, as perhaps he was. He sort of tilted his head and stroked his beard and asked about the prognosis, and the doctor said, "Six to eighteen months."

"And there's no effective treatment?"

The doctor didn't say no, but he didn't say yes. He explained what could be done, that everything possible would be done, an oncology team was already in place, he'd just gotten off the phone with a specialist, and so on, but Oliver cut him off. He said he was not interested in "prolonging life just for the sake of prolonging life." Two of his brothers had died of cancer (different forms of cancer), and both had regretted undergoing horrid chemotherapy treatments that had done nothing but ruin their last months.

"I want to be able to write, think, read, swim, be with Billy, see friends, and maybe travel a bit, if possible." Oliver added that he hoped not to be in "ghastly pain" or for his condition to become "humiliating," and then he fell silent.

I looked over at the young fellow standing by the door; his brow was damp with sweat. My right hand reached for Oliver's shoulder, my left hand to steady myself on his chair.

I'm sure we discussed details of the liver biopsy he would have at the hospital the following week. A nurse came in. We had to review some paperwork. But I don't remember much else about the discussions that followed. Somehow I got us back down to the parking garage, and I drove us home. It was dark by then, and the traffic slow.

Oliver made a few calls on the way, calmly relating the news to his close friend Orrin and to Kate. Only once did strong emotion come into his voice. To Kate, he said in no uncertain terms that he wanted his just-completed memoir to be published as soon as humanly possible; it had already been slated for the fall, nine months later, which he said "would be too late" for him to see. Kate said she would contact his publisher and his agent immediately. I remember holding Oliver's hand when I could take mine from the wheel, and knowing, without saying so, that our life and his life and my life had all changed in ways I could and could not comprehend. I just drove.

———————

WE HAD met with the doctor on a Thursday. The next day, we went swimming at noon, as we always did on Fridays, and then spent a quiet weekend together, taking walks, reading, listening to music, going to the open-air market at Abingdon Square, cooking, both of us trying to absorb the overwhelming news. Oliver consulted with a few colleagues, including the ophthalmologist who had treated his cancer years before; he had had a chance to look at the CAT scan, too. Recurrences such as this were considered extremely rare, yet the consensus seemed to be that the preliminary diagnosis was most likely correct and that treatment options were few.

On Saturday night, we got stoned—if only as a diversion from thinking the unthinkable. Oliver didn't like to smoke weed; he preferred edible cannabis chocolates made by a friend of mine, Laura, a trained pastry chef. These were very delicious and very potent. He became extremely cheerful, hilarious, and animated.

"What are you seeing?" I asked at one point, as he lay on the couch.

"It would take a hundred pages a minute to tell you," O said matter-of-factly.

A moment passed, then he reported with a gust of giggling, "I just had an astounding alteration of perception! I opened my eyes, and in place of my body all I could see was my feet—my comically large, flat human feet. They seemed very brightly colored!"

"What color?"

"Oh! Every color!"

We laughed a lot, laughter itself being something that Oliver felt was very good for one—stimulating pleasure-inducing neurochemicals —and, in turn, good for us as a couple. The effects of all this essentially harmless pleasantness wore off after a couple of hours, at which point we ran a bath, sharing the water in his giant tub, while listening to music and sipping our favorite liquor, Brennivin.

———————

OVER THE weekend, Oliver mentioned a few times that he was considering writing "a little piece" about receiving his diagnosis. And on Sunday night, after we had made dinner and cleared the dishes, he took up a small notepad and his fountain pen. At the top of the pad, he wrote, "Sad, shocking, horrible, yes," underlining each word, "but . . ."

(Oliver often said that *but* was his favorite word, a kind of etymological flip of the coin, for it allowed consideration of both sides of an argument, a topic, as well as a kind of looking-at-the-bright-side that was as much a part of his nature as his diffidence and indecisiveness.)

Next, he proceeded to list eight and a half reasons to remain hopeful; to feel lucky at the very moment when one might reasonably feel most unlucky.

He wrote quickly, thinking aloud as he wrote, then making one or two corrections with a red-colored felt pen. Once he'd finished, he handed the pad over to me to read:

But . . .
1. AN EASY DEATH (relatively)
2. TIME—to "complete" life
3. LOVING SUPPORT (Billy, et al.)
4. BOOK PUBLISHED (open at last about myself)
5. MORE GOOD WORK
6. ENJOYMENT ALLOWED
(6-A) MJ now legit
7. BEST DOCTORS, TREATMENTS, ETC. AVAILABLE
8. PSYCHIATRIC SUPPORT

I got choked up, the reality of what he and he and I were facing made all too real by his words on paper. I felt, too, amazed that he was able to collect his thoughts and do so with such aplomb and straightforward eloquence. Unlike myself—more of a melancholic sort—Oliver always was essentially cheerful in temperament, and this list—including the making of a list, an ordering and structuring of the world, not unlike his beloved periodic table of the elements—was very much in character.

As a doctor himself, he had seen more than the average share of grisly and protracted deaths, and he knew that—all things considered—there were probably worse ways to die (ALS, for

instance, or, for that matter, the post-encephalitic condition that had doomed his *Awakenings* patients); hence, this form of liver cancer would bring a "relatively" easy death, so long as it didn't metastasize to his bones or lungs.

For myself, I felt particularly grateful for number two on his list, as I told Oliver: "I'm thankful we have time, will at least have more time together, however much it is. Even just this weekend, even if this weekend is all we have? That's more than I had at the end with Steve."

He understood, and agreed. But for him, "time" meant far more: time to "complete" his life on his own terms, finally coming out publicly as a gay man through his memoir, time to see the book published, time to write pieces he had wanted to write, time to get things in order, time that a sudden and unexpected death, or the slow demise of an illness such as Alzheimer's, would not allow.

As for number six, "enjoyment," from the very beginning that was equally important, too, and it was with an impish sense of humor that he had gone back to the list and added "#6-A," which indicated that "MJ"—i.e., marijuana, or cannabis—could now be legitimately, medically, and without any guilt whatsoever consumed.

I have kept this list, for those eight-and-a-half tenets helped guide him (and me) in the months ahead. It also became the basic blueprint for his essay "My Own Life," which originated over the dinner table as well.

Two, maybe three, nights after he'd jotted his little list, I asked Oliver what he had in mind in terms of the essay he was considering.

"Well, let's see . . ." He paused. "I suppose I want to begin by saying that a month ago, I felt that I was in good health. But . . . now my luck has run out . . ."

"Hold it," I interrupted, "let me get a pen."

I did so, and a notepad, and I scribbled what he had just said. "Okay, keep going."

Oliver started over, his voice now more self-assured: "A month ago, I felt that I was in good health, even robust health. But my luck has run out—last week I learned that I have multiple metastases in my liver . . ."

From there, Oliver dictated the entire essay, nearly verbatim to the version that would eventually appear in the *New York Times*, the main difference between them being that his original included longer excerpts from his beloved philosopher, David Hume. It was clear to me that he had been "writing" this essay in his head over the past several days—and now, one perfectly formed paragraph after another spilled forth. It was astonishing. I handwrote, as rapidly as I could, as he spoke, typed it up that night, and brought it back to him the next morning. He spent several days tinkering with it, both Kate and I reviewing drafts, but then he set it aside. Oliver worried that his feelings were perhaps too raw, and felt it was too soon to publish it, given that most of his friends and family members did not yet know his news.

In lieu of any experimental treatments, Oliver made the decision to go ahead with a surgical procedure called an embolization, which would cut off blood supply to the tumors in his liver and therefore kill them off—temporarily (they would inevitably return, he was told). Surgeons would do two separate embolizations, one for each side of the liver, allowing a few weeks of recovery in between procedures. Dramatically lowering the "tumor burden" held the promise of offering him several more months of active life.

The first embolization was scheduled for mid-February. Literally as we waited in the hospital for him to be admitted for surgery, Oliver

suddenly turned to Kate and me and said he felt the time was right to send the piece over to the *New York Times*. Neither of us questioned him; we just said, Okay. I went into a bathroom at the hospital and called our mutual editor at the *Times* on my cell phone and, confidentially, shared with him the news of Oliver's terminal diagnosis. After Oliver had been admitted, Kate e-mailed the essay to him, and we heard back almost immediately: They wanted to run the piece the next day. We asked for one extra day—to get Oliver safely through the procedure first—and they agreed. Oliver's essay "My Own Life" was scheduled for publication on February 19, 2015.

"My Own Life"

NOTES FROM A JOURNAL

2-17-15:

In post-surgery recovery: The only thing that briefly distracts O from the pain is when I read to him from a book on the elements. Cutting off blood supply to the tumors in the liver may sound somewhat benign, but the body revolts with full force against such an intrusion.

He repeatedly tears off his hospital gown because he is in so much pain that even the thin cotton material causes discomfort. The young female nurses act scandalized by this and keep trying to cover him up.

At one point, O yells out in exasperation, "If one can't be naked in a hospital, where can one be naked?!"

I hear a nurse in the hallway join me in laughter.

I cover his genitals with a washcloth when the morphine finally kicks in and he falls asleep.

It takes until midnight before we get a hospital room.

———————————

2-24-15—back home after six days in hospital:

"I am going to lie down on the bed, come and talk to me," O says.

I curl up next to him, an arm over his chest, a leg over his legs. His eyes are closed, and for a moment I think he has fallen asleep, but no: "When you can't tell where your body ends and the other's begins, is that primal, or signs of an advanced evolution?"

I pull him in close, his head on my chest.

"A little of both," I whisper.

2-27-15:

I brought O a few of the letters and e-mails written in response to his *New York Times* essay:

I: "How'd it feel to read those?"

O: "Good!"

I: "You have about 800 more to go."

O: "I'd like to see all of them."

2-28-15:

I looked in on O when I woke at 6:20. To my surprise, he was lying on top of the covers, his hands resting on his belly, and staring at the ceiling. *Oh no, has he been like this all night*, I thought, *sleepless?*

He heard me make a movement and noticed I was standing in the doorway.

"I was thinking about the brainstem," he said in a clear, strong voice.

"Yeah?" I slipped into the room and onto the bed. He put his right arm around me. I could hear his slow, steady heartbeat—the heart of a swimmer.

"Yes, you see—" and, with his eyes closed as if seeing the pages in his mind, he proceeded to describe in the most careful detail the workings of the autonomic nervous system, gradually zeroing in on the topic of "a general feeling of disorder," a state the body enters when the smallest change—whether intestinal, vascular, hormonal, neurological, cellular, "what have you"—triggers a "cascade of unwellness." He used migraine to illustrate the concept.

He hardly took a breath for thirty-five minutes. I considered getting up to retrieve the tape recorder, but this might have disturbed the flow of his thinking.

Finally, O came to a pause. "So, you see—just a few morning thoughts." He chuckled at himself.

"Just a few." I gave him a kiss on the cheek. "You have to write this out," I said firmly, "and you've already got your title: 'A General Feeling of Disorder.'"

He agreed.

We both breathed together for a half a minute.

"Now, if you would be so kind? Would you replenish my little water bottle and get me an Omeprazole? And then, my eye drops?"

"Of course. By the way, how did you sleep?"

"Very well, thank you."

———————

Undated Note—February 2015:

Happily, so happily, back at the pool:

O, swimming, turns to me at the end of the lane: "Let's do more."

I: "Yes!"

How those three words define our life right now: *Let's do more.*

———————————

3-2-15:

On the same day that O had his biopsy, I learned that Ali's shop is closing. Same old New York story: landlord raised the rent on the lease and his boss has to close the store. Fortunately, he also owns the "sister smoke shop" half a block down, and Ali will now work there. But if that shop doesn't make it, that's it.

"This is only America, this happens," Ali railed angrily when he gave me the news a few weeks ago. "My country? Your grandfather own a shop, then your father have it, then you. But here?" He shook his head. "Here, you can have it ten year, twenty year, thirty year, and it's not yours."

I listened. I sympathized. I tried to be optimistic. "Maybe you should have a party on the last day," I said. "Neighbors will come."

Ali looked aghast. "You don't have a party when you lose! No one want to come to that. You have a party when you win. We have a party when we start the other store."

"You mean, when the Mayor of Eighth Avenue takes office at his new headquarters," I said, teasing him.

"That's right," Ali said, "that's right."

Now, they are doing the hard, awful, dirty work of cleaning out, emptying, and gutting the shop. I stopped by today. It was a mess. Ali, Bobby, and their boss (a soft-spoken Indian gentleman whose name I can never remember) looked exhausted. I asked how it was going.

"Everything upside down," Ali said. "Nothing easy."

And yet, and yet . . . Ali added, referring to the three of them, "One Muslim, one Hindu, one Sikh: You see, we all here. Everyone work together. Back home, everyone fight."

———————

Undated Note:

O, as he goes over final galleys for his book:

He insists on crossing out clauses suggested by a copy editor that define or explain an unusual word or term he has used: "Let them find out!" he says, meaning—make the reader work a little. Go look it up in the dictionary, or go to the library!

———————

4-2-15:

O, when I accidentally dropped a carton of cherry tomatoes on the floor:

"How pretty! Do it again!"

So I do.

O: "Your friends must be clamoring to see you."

I: "Maybe, I don't know. This is where I want to be—with you."

O: "Mad. But thank you."

Back Home, March 2015

4-22-15:

O: "The most we can do is to write—intelligently, creatively, critically, evocatively—about what it is like living in the world at this time."

EVERYTHING THAT I DON'T HAVE

Stories like the one I'm about to tell happen to me often enough that they no longer surprise me. Even so, I don't take them for granted. This time it was a Sunday in April. I'd been up on Twenty-Sixth or Twenty-Seventh taking pictures, then decided to head home down Eleventh Avenue; it was about four o'clock and getting cold. I was wearing shorts. While crossing Twenty-Second, I spotted a young man who'd fitted himself snugly sideways into a street-level recess in a brick building and was talking on a phone. He looked like a corner piece of a jigsaw puzzle. The street was otherwise empty. I approached him, pointed to my camera, and mouthed the words "Can I take your picture?"

He nodded calmly, still talking, with a kind of Mona Lisa smile (and her dark eyes too); it was as if he'd been waiting for me to come; as if this phone call was just killing time till I finally showed up with my camera. Sometimes it's like this; this is the magical part of photography: how sometimes it seems like a picture I see has just been waiting for me to come take it. Here I was.

I knelt down and took a bunch. He moved into different positions, without my directing him, like a parody of a model, like Zoolander; it was funny. He finished his phone call, but kept acting like he was on the phone—for the sake of my photo. This made me laugh. The moment he'd started doing that, the pictures started looking fake. I stopped. I walked closer.

"Who are you?" he asked. I told him. He said his name, it started with a D, and he said he was an artist. He had a foreign accent I couldn't place. He scooted over on his little shelf, protected from the wind, and I sat down right next to him. It was a tight squeeze, so our thighs touched, and far warmer here than on the street. There was an instantaneous intimacy, as if we'd known one another a long time, even though I hadn't caught his name and I couldn't understand everything he was saying.

He asked me more about my pictures, and I showed him my website on my phone. He looked carefully at many of the pictures, not saying much, murmuring, "Nice, nice, nice . . ." Then he showed me photos of his paintings—strange, vivid canvases of women with red hair. Not red—"Ginger," as he said, "ginger." He said he was obsessed with ginger. He showed me a photo he'd taken of a woman with red hair. He zoomed in on her hair until the image became a pure abstraction—shimmering cylinders of gold and orange and red. "See?" he said, shaking his head in wonder, "it's impossible to understand the source of that color."

I got it; I got what he was talking about. I told him he should do paintings from those enlarged photos—abstracted images of strands of ginger hair.

"I love you," he said with a deadpan look, "let's get married." He was joking—I'd known the moment I sat next to him that he was

straight—but there was something sincere about it, too. I actually could marry him, I thought to myself—let's say, if he needed a green card: Men can marry one another now, and women, women: This still amazes me. Recently I met an attractive young man, just twenty-two or so, Dominican, who said something about "me and my husband," and I thought for sure he'd gotten the word wrong— that he'd meant to say "boyfriend." But no: They had rings and had gotten married at City Hall. I thought to myself: *Twenty-two is way too young to be married*—male, female, I don't care.

The artist and I sat there for a while and showed each other pictures on our phones. It was sort of like—actually, it felt a lot like— two boys trading baseball cards, although I was old enough to be his father. He showed me a photo of himself and friends at a party in Brooklyn—it all looked drunken and wonderful, like the kind of thing you'd still be recovering from at four o'clock on a Sunday afternoon.

He reached into his backpack and took out two small oranges— clementine oranges—and gave one to me. "I'm like your mother, I take care of you."

I laughed, disarmed, and was touched. This was all so strange, but so normal. I said, "It feels like I'm having a déjà vu."

He disagreed. "For me, this is a nostalgia."

The orange was delicious. He asked me more about myself, about my books and writing, my agent and publisher. "Will you be my agent?" he said.

"What? You want me to be your agent?"

"I want everything from you that I don't have," he said.

The line stopped me. It was both very beautiful and very spooky.

"You don't want everything I have right now, trust me," I said.

I impulsively patted his head. He had the softest hair.

"I have to go. Let me take one more picture of you," I said, and I went to one side and took one, his face peeking out from the wall. We exchanged phone numbers then and promised to hang out one day and see some art.

"We'll go to the opening of your first exhibit together," I said.

He agreed.

We said goodbye, and as I walked away I immediately sent the young man sitting in the wall a text message: "I want everything from you that I don't have," it read.

NOTES FROM A JOURNAL

4-14-15:

I have been taking pictures constantly—every day, hundreds sometimes.

If I can't get outside, I bring New York inside my apartment—do portraits of people I meet on the street.

At the end of each day, I show O my pictures. He reads to me what he's written. He is working on five or six things at once. As when he was a boy, his fingers are stained with ink.

———

Undated Note—May 2015:

Intensely creative and productive time for both of us—

Some days, I feel like Sylvia Plath married to Anne Sexton— or is it Anne Sexton married to Sylvia Plath?—but without the depressions or suicides.

Just poetry.

———

5-1-15:

On a flight to London, where we will stay for a week, seeing O's friends and relatives, perhaps O's last time—then to Dorset for three days:

O reads an article in *New Scientist* about a study showing that when dogs look into their masters' eyes (and vice versa),

oxytocin (the "love hormone") is released; this helps explain, in part, the bond dog owners may feel with their animals.

He puts down the magazine. "We should look into each other's eyes more," he says.

"Let's do it right now," I say, and we do.

5-6-15:

At lunch, the husband of O's niece tells me how he first met Oliver, some forty years ago, at the home of his future father-in-law, O's older brother David: Nicky looked out the window, where he saw a large, bearded man lying on the grass in the garden. "What were you doing?" Nicky asked once he came indoors.

"I was wondering what it is like to be a rose," replied Oliver.

6-4-15:

I found a great, papered-over wall on a fairly empty street— an interesting backdrop for photos—and loitered there for a while, waiting for the right person to stroll into the frame. I tried one or two passersby; the chemistry wasn't right. And then out of the corner of my eye, I saw a trio of tall, exotic-looking creatures approaching; baby giraffes came to mind.

Before I'd even finished my practiced pitch, they were saying, "Sure, man," and assembling into place. When I told them my "no cell phones in photos" rule, they complied, pocketing

them without complaint. "This is crazy, man, we just came from a shoot—down the block," said one.

"Gucci," said another.

(This is so not-Gucci, I thought to myself.)

They smelled of weed.

I got the group shot, and then said, with an authority I don't normally possess, "Okay, now I want to do each of you solo." The three young models nodded, compliantly. One stepped up. He was wearing a T-shirt with Mona Lisa on it. I asked him to take off his sunglasses, and he did. And then, like auto-focus on a camera, his features instantly froze into an image of boyish handsomeness. (How do they do that?) I took a couple, he stepped aside, and his friend—a blond—took his place.

Finally, the tallest of the bunch (clearly the leader of the pack, the Alpha Model, if you will), stepped in. He was English and dashing. "I can't be holding this in a picture," he murmured, referring to the joint pinched between two fingers. "Want a hit?"

"Sure," I said. It was the very end of the joint, and as I took a hit, finishing it, I flashed on how when I was in high school and would get stoned with friends, we always talked about how you'd get most high at the end of the joint—because supposedly that's where all the resin accumulated—and how if you held the hit in your lungs as long as you could, you'd get a head rush that would make you see things.

I don't know if that's true or not, but when I looked through the camera lens and took picture after picture of the

handsome young Englishman, my brain bloomed. All I could see was beauty.

———————————

7-5-15:

I went up to the roof to sit in the sun, no sunscreen, no hat on my bald head, which I know is the dumbest thing you can do, especially when your partner has a terminal form of melanoma. But I didn't care; it was a long cold winter here, and I felt like I was still thawing out.

I plopped into the hammock and soaked it up.

Paradoxically, the heat made me think of the cold of winter, the bitter, dry cold, January, February, March—lost months, when O got his diagnosis, all the tests, the two surgeries, standing on First Avenue in the freezing wind trying to get a cab—no luck—nights spent sleeping in a recliner at the hospital next to O's bed.

Not bad memories, exactly, but . . . But . . .

I am reminded of a segment of *60 Minutes* I saw years ago that focused on a new drug which was found to be effective in people with PTSD. The drug supposedly helped to erase memories of the traumatic event, allowing people to move forward with their lives (at least, that's how I remember it). And the central question posed by the reporter from *60 Minutes* was, If you could take a drug to forget something, would you?

I have thought about this many times in the years since, and my answer remains unchanged: No, I never would.

Yet not wanting to forget something is not the same as wishing to remember it better.

7-7-15:

I do fifty push-ups twice a day while O sits at his desk and counts them out by naming the corresponding elements: "titanium, vanadium, chromium, manganese, iron, cobalt . . ."

O, proudly, playing a new Schubert piece, and with great flair demonstrating how it requires "crossed hands."

I am quite amazed and impressed, and I clap.

7-8-15:

The day before O's eighty-second birthday, and we got bad news with his latest CAT scan—bad—much worse than expected:

Not only have the tumors regrown, the cancer has spread: kidneys, lungs, skin. They are no longer talking about doing another embolization . . . Doctors advise starting Pembro infusions—the immunotherapy still in clinical trials.

Scared.

O wants to go ahead with his birthday party, and doesn't want people to know. "Auden always said one must celebrate one's birthday," he says.

Undated Note:

"Hey, Beautiful," I say to O, whenever I come into the
bedroom.

———————

7-9-15—O's birthday:

At his party—

O asks me to go get the bottle of 1948 Calvados—a rare
brandy given to him as a gift years ago and sealed in a wooden
box. I open it for him.

I: "Do you want a glass?"

O: "No," he says, and takes a swig, eyes closed. "Lovely," he
pronounces and looks around the room. "Who would like
some?"

Later, he tells me he'd forgotten that he had left the Calvados
to a friend in his will.

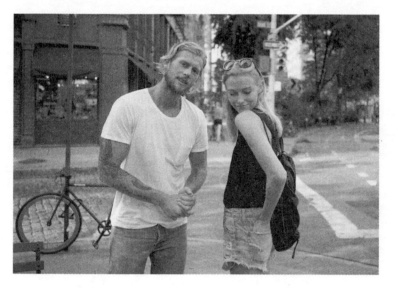

First Date

A PENCIL SHARPENER

"**H**ello, Sir!" I said.

"Hello, Sir!" said Ali, smiling.

He sure is a handsome devil, I thought to myself—his trim moustache, his slicked-back black hair—a Pakistani Omar Sharif, *Funny Girl* period.

"How is everything?"

"Everything good," Ali said, reaching over the counter to shake my hand. He has seemed as happy as ever in his new shop.

Just then, a customer stepped in and asked for a pack of cigarettes—American Spirits. He was in his late twenties and had blond hair. He wore a classic, light-blue striped seersucker jacket, a crisp white shirt, and jeans rolled at the bottom, and carried a Jack Spade canvas briefcase. He looked like someone who designs apps for iPhones. He looked like a million bucks. He looked like he'd be a millionaire one day.

As he reached for his wallet, he remembered something—I could see this in his body even before he uttered any words: "Oh! I almost forgot—and one of your pencil sharpeners!"

This I did not expect—would not ever have expected—him to

say. I watched in disbelief as Ali directed him to a back corner of the smoke shop.

A pencil sharpener? Who buys pencil sharpeners anymore? Who sells them?

Ali read my mind: "Left from the stationery store," he said in his deadpan way.

Ah, yes, the failed stationery store that his boss had for six months before giving up on it—more money in lotto tickets and cigarettes than in paper clips and notepads, I guess.

Ali and I watched silently as the young man in the seersucker jacket reached up to take something from a high shelf and returned to the counter holding, yes, a pencil sharpener. It was purple. "Last one," he murmured with a tone of amazement.

I don't remember if I asked the young man, or if he simply saw the questioning look on my face, but he turned to me and said, "This is the *best* pencil sharpener." But he didn't stop there. "The *best*. You can't find another one this good."

I nodded in agreement, convinced.

"I ran over my old one." He looked at Ali. "That was the last one you had, too, wasn't it?—My lucky day."

Ali looked completely blasé: "Hundreds more in the basement."

This made me laugh.

I watched the young man pay Ali and noticed just then that the pack of American Spirits was exactly the same light blue as the stripes on his jacket, the same light blue as his lighter, and the same light blue as his dazzling blue eyes. I had no doubt that every detail of his appearance had been thought out, refined, tested on previous nights—selfies taken and studied—until he had arrived at this curated version of himself, equal parts *Mad Men*, *Entourage*, and

This American Life. I could easily envision his apartment, with its retro touches, and his Kate Spade-accessorized girlfriend, and his terrier dog.

But still, I had a question for this young man: "Why a pencil sharpener? Why a pencil?"

"Hey, I make mistakes sometimes."

"Excellent answer," I said.

The young man waved "so long" and was out of there, probably meeting friends at the Art Bar next door.

I said good night to Ali and headed south on Eighth toward a favorite neighborhood restaurant. On my way, I walked through Abingdon Square Park. To enter was to step back in time—twice: once, to an earlier age in New York, the early twentieth century, with the wrought-iron lampposts and benches, and secondly, to 2009, when I first moved here and discovered this park on walks on insomniac nights. A wave of nostalgia washed over me. I couldn't just dash through on my way to the restaurant. I had to sit down for a moment and soak it in.

The light here was so pretty—the yellowy light from the lampposts, light from apartment windows, some stars overhead. At this hour, just before closing, there were only a few people here in the park. None were talking on cell phones or even looking at cell phones. There was a homeless man splayed out on one bench, a couple talking quietly, a guy with a dog, and to the far right, sitting right under a lamppost, a tall, dark-haired, bearded man reading a book and smoking a cigar. He was perhaps in his mid-thirties. His wife and baby daughter were at home nearby, I imagined. He was stealing a little time for himself. The cigar had just an inch or two left—he had been here awhile. He was the very picture of a man, a

certain type of very masculine man: a New Yorker, but somehow imbued with the spirit of his European forebears, too.

I couldn't take my eyes off of him. It was such a beautiful picture, him sitting there under that light. He was such a beautiful picture. He pulled on the cigar, leaned over, studying his book. I wished, I so wished, I had my camera with me; I would have taken a photo. I tried to dissuade myself from doing so but couldn't—I had to at least go talk to him.

I asked him what he was reading. He showed me the cover: *Moonwalking with Einstein*. "It's supposed to help you remember better," he said.

I nodded as if I understood, but I didn't, not really. Remember what? I wondered. Moments in his baby's life? Passages of poetry? Facts, numbers, figures that would help him make more money? Or maybe even nights like this?

I left him to his book and his cigar and said good night.

As I walked away, I pulled a pencil from my pocket and made some notes for my journal.

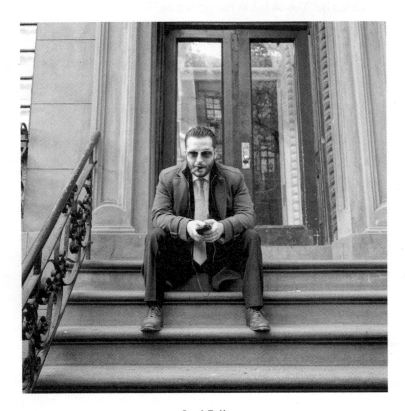

Good Fella

NOTES FROM A JOURNAL

7-11-15:

Woke at 2:30 A.M. to O's restlessness in bed and whispered, groggily, "You okay? What's going on?"

"Hot! So hot!"

His skin was indeed hot to the touch and damp, even though the room was cool.

I pulled back all of the bedclothes, helped O remove his pajama trousers and T-shirt, went to the bathroom and got a cold, wet washcloth, put the cloth to his brow, then used it to cool and wash his naked body. I put a dry bath towel on the bed, changed his pillowcases, got a glass of water. Then I split a Xanax in two, and gave him half.

"Here," I said, "put this under your tongue." I didn't ask, I told him. He did so, and I gave him some water to wash it down. We got back into bed, cuddled.

"Is this what you did with Steve," he asked, "when he had night sweats?"

"Yes," I whispered, "yes."

This morning: A bowl of blueberries for breakfast. "Each one gives a quantum of pleasure," O says with delight, then reconsiders, "if pleasure can be quantified."

7-13-15:

Very, very tired, I did the dinner dishes quickly, gathered my things, and earlier than usual, told Oliver I was heading to bed and said good night. He agreed, he was exhausted, and we kissed. But then as I headed for the bedroom, O called to me from his desk, "Do you know why I love to read *Nature* and *Science* every week?"

I turned. "No," I shook my head. I was almost confused; this seemed such a non sequitur.

"Surprise—I always read something that surprises me," he said.

———————

7-15-15:

O no longer wants any visitors to the apartment unless he expressly invites them: "I don't have time to be bored!"

When he is not resting, he is working on new pieces nonstop.

———————

NOTES ON A PAD:

7/17, THURSDAY: LaGuardia to Durham, depart @ 2:29 P.M.; arrive @ 4:20 P.M.

7/19, SATURDAY: Durham to LaGuardia, depart @ 11:05 A.M.; arrive 12:39 P.M.

———————

7-18-15:

Visiting the Lemur Research Center at Duke University this afternoon.

We slept okay, though O woke at 3 A.M. with terrible cramps in his calves and feet, his feet fixed into a painful dorsal flexion, so hard and rigid it took half an hour to massage them smooth. Is this from dehydration? His urine, dark again.

Evening:

"I think that is the most wonderful sight I have ever seen," O said quietly as we drove away from the Lemur Center. "It is the *vitality* of the lemurs that is so beautiful . . . and the dedication of those who care for them."

7-25-15:

In the country: O is finishing one essay, working on two others—at least two others. "How's the writing going?" I ask, waking from a nap.

He smiles mischievously. "I meant to stop, but I couldn't." And he goes back to it. I watch. He doesn't have a fancy desk here; it's just a folding table. All he needs is a pad and his fountain pen and a comfortable chair. Completely immersed, he whispers to himself as he writes—consciousness half a step ahead of the nib of his pen.

Later, we go for a swim. The water in the pool is a bright emerald green, caused by an excess of copper and iron in the well.

"You are swimming in the elements," I tell O, "swimming in a pool of copper."

"Lovely," he murmurs, doing his backstroke.

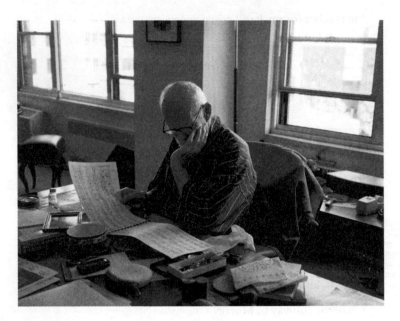

Studying Bach, August 2015

8-1-15:

He plays Beethoven—he never used to—long, haunting
pieces, complex pieces—whereas he used to only play Bach
preludes, and in stops and starts.

He reaches for my hand when we walk, not just to steady
himself but to hold my hand.

———————————

8-4-15:

Back from the hospital:

The surgeon implanted a catheter in his abdomen to help
drain off the fluid accumulating from the tumors: O, in pain,
uncomfortable, terribly nauseated. Doctors say he must eat
and drink to keep his strength up. The only thing he can
think of that he'd like to eat is gefilte fish.

We order from Russ & Daughters, and decide to try others for
comparison.

I take the subway to Murray's Sturgeon Shop on the Upper
West Side. It could be delivered but I am frankly relieved to
get out of the apartment, though it's a grim, rainy, humid
August day.

A woman waiting in line overhears me say that I am picking
up an order for Oliver Sacks.

"*The* Oliver Sacks?" she can't help asking.

I nod.

"He's a very great man. I'm so sorry that he's ill."

The old Jewish man behind the counter nods and murmurs, "Yes." I try to pay the bill but he refuses to charge me.

My eyes fill with tears, and I say thank you.

I cry on the way to the subway, glad for the rain.

———————————

Undated Note:

I find O lying on the bed, eyes closed: "Letters to various people are writing themselves in my mind," he explains— farewell letters to friends and family members. He later begins dictating these to Kate and to me; it's almost hard to keep up, he has so many he wants written. Each one is thoughtfully personalized, and of course soon he begins receiving letters back.

I feel very self-conscious about this: Should I write a letter to him, too?

One day I simply blurt out, "I hope you'll forgive me if I don't write you a letter."

"Is that the start of a letter?" O says, smiling.

"Yeah, one in which I don't know what to say. How do I ever say everything you mean to me?"

"Come here," O says, and hugs me.

———————————

8-10-15:

O is working on a new piece: "Sabbath." Every now and then, a little request comes, always phrased politely: "If you would be so kind: Look up something for me on your little box?"

"Little box" is his name for an iPhone, a name he finds too ugly to pronounce, to speak—"It's not even a word," as he points out, "it's a brand." Sometimes he calls the phone my "communicator," as if out of *Star Trek*.

Today, he wants me to look up the meaning of the Latin "*nunc dimittis*."

As is almost always the case with O, it wasn't necessary: He'd had the definition exactly right in the first place: *nunc dimittis* is "the final song in a religious service."

8-11-15:

I, sleeping on the floor right outside the bedroom (so as not to disturb him), wake to the sound of O yawning—such a sweet sound, like a puppy's.

"I had a beautiful sleep!" he says—a rare thing for an insomniac like him to say.

It is 2 in the morning. He needs to use the bathroom.

"Hug me," I instruct. He wraps his arms around my neck, I pull him toward me, get him seated on the side of the bed, then stand him up, wait a moment to make sure he is stable. I kiss his neck. "This is my favorite part of the day," I tell him.

O is increasingly letting go, letting things fall away, the inessential: Just days after he was devouring gefilte fish with such relish and delight, now it is only the jelly he likes—"No more fish balls."

Even swimming no longer appeals—"The ratio of risk and unpleasantness far outweighs the benefit at this point," mostly because of the catheter, the risk of it getting infected.

———————

More and more, unconsciously, he keeps his eyes closed all the time. His eyes are closed when he eats, when he talks, when we read to him, as if he saves his eyesight only for writing.

And yet, also, all is not grim.

Last night, I went in to say good night:

"My love," he says as I lean over to kiss him.

"Sleep well," I say.

Pause.

"What did you say?" O asks.

"Sleep well."

"Oh, I thought you said, 'Wow!' I didn't know what you were referring to but it seemed a very positive thing to say."

We giggled.

———————

8-15-15:

O can no longer read easily—it's too difficult to hold the
magnifying glass and book—so he has asked us—Kate,
Hallie, Hailey, Orrin—any of us who are with him—to read
to him. He does not like professionally recorded audio
books—not at all.

We are reading H. G. Wells stories, *Men of Mathematics*,
Sherlock Holmes, *The Odyssey* . . .

"I love it, I love reading to you," I tell him. "I feel very close to
you."

He nods. "It becomes another form of intimacy."

8-16-15:

3 A.M., walking into his room to check on him:

O: "How did you know . . .? How did you know I'd be
awake?"

"I could hear you smile," I say.

He woke twice last night. The first time, we go to the kitchen.
I get him seated in a chair, and he eats orange Jell-O
("Refreshing!" he murmurs) and sips some protein-milk.
Later, his second waking, I bring the Jell-O to him as he sits
on the bed. He is sweetly groggy. I sit across from him. He
pauses, looks at me quizzically: "We're not going to catch a
plane anywhere, are we?"

"No," I reply quietly.

O smiles, then proceeds to tell me about a "mad, ferocious dream," involving trying to get an Edsel car, improbably, through a too-small doorway—finally, people had to knock down the whole door to get the car through.

"Have you ever seen an Edsel?" he asks me.

"Only in pictures."

"An absurd car," he says, shaking his head.

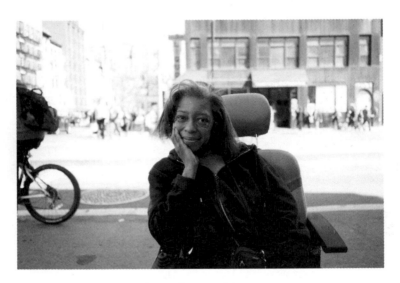

Karen, Fourteenth Street

8-16-15:

"I say I love writing, but really it is *thinking* I love—that rush of thoughts—new connections in the brain being made. And it comes out of the blue." O smiled. "In such moments: I feel such love of the world, love of thinking . . ."

———————————

8-22-15:

O, this morning: "You can throw away my swim things, and keep for yourself what you think you can use."

———————————

Suddenly, from bed, telegraphic: "Manuscript! I want to look at the manuscript. And a pencil! My reading glasses!"

My heart breaks.

———————————

8-23-15:

"What are your wishes, Dr. Sacks?" said the hospice nurse. "How would you like to pass?"

"At home," answered O in a clear, steady voice, "with no pain or discomfort, and with my friends here."

What bravery it took to say that, I thought to myself— bravery that must go unremarked upon because of course it must. But bravery that I will remember nevertheless.

"Okay, good, I'm going to make sure we honor your wishes," the nurse said.

"Thank you," he said.

8-28-15:

O, who has had no appetite, suddenly asked to have smoked salmon and Ryvita for lunch. He insisted we get him out of bed, into his "dressing gown," take him to his table, and "to see my piano." We brought a plate to him: With incredible dignity, and slowness, he carefully cut a single piece at a time. He could only eat three bites. And when I suggested something sweet—some ice cream? He said, "No, a pear." He had one slice then asked that we take him back to bed.

8-29-15:

I am at his side, in his bedroom, where Kate, Maurine (our hospice nurse), and I have been keeping a special watch since 5:30 A.M. That's when Maurine woke me in the other room, "Billy, come now—his breathing has changed."

It has slowed to just three or four breaths per minute—long silences in between. He is no longer conscious. He is stretched out on his bed diagonally and looks comfortable. Maurine, who has been at the side of many patients as they die, tells us this is the last phase, but that it could go on for many hours, days maybe.

A little while ago, I looked around the room, crowded with bedsheets, towels, Depends, pads, medications, an oxygen tank and other medical equipment, and I began clearing it out, all of it. First, I brought in stacks of all of O's books, cleared a bedside table, and put them there. I brought in a cycad plant and a fern. Kate joined me, and we cleared more space, making room on another table for some of O's beloved minerals and elements, his fountain pens, a ginkgo fossil, his pocket watch. Elsewhere, a few books by his heroes— Darwin, Freud, Luria, Edelman, Thom Gunn—and photos—his father, Auden, his mother as a girl with her seventeen siblings, his aunts and uncles, his brothers. We brought in flowers, candles.

I am heartbroken but at peace.

Last night, before getting some sleep, I came in to see if he needed anything. I tucked him in and kissed his forehead.

"Do you know how much I love you?" I said.

"No." His eyes were closed. He was smiling, as if seeing beautiful things.

"A lot."

"Good," O said, "very good."

"Sweet dreams."

Oliver's Periodic Table

HOME

Two men from the funeral home got to the apartment at around four A.M. on Sunday morning. They were both very stocky and looked very strong, tough somehow, yet emanated gentleness, quietness. They went into the bedroom and took care of Oliver. They could not have been more respectful and polite. At that hour, there was no one on the sidewalk or street when we brought Oliver's body down on a gurney, and they carefully placed it inside a waiting van. I felt grateful for that: the lush cover of darkness and warmth, not unlike the velvet blanket they had placed over him.

I tidied up a bit in his apartment and then went back to my place. I got into my own bed for the first time in more than a month; it seemed too large for me. By now, it was about six o'clock. I closed my eyes. I felt tired, grateful, peaceful, battered, sad, wise, old. I felt like Odysseus reaching shore.

———

I LEFT MY apartment for the first time that evening. It was absolutely pouring rain, a drenching summer rain, the kind that cleans the

sidewalks. I didn't know what to do with myself. I went to see Ali at his shop. He asked how I was. "Oliver died today," I said.

Earlier, I had sent some e-mails to friends and family, but this was the first time I had actually said those three words aloud.

At first Ali looked like he didn't understand what I'd said—he had always known him as The Doctor, not Oliver—but then he knew. He expressed his sympathy, tenderly, and said he would pray for us. I thanked him. I stood there awkwardly for a minute, and then Ali came from behind the counter to stand with me. There was no one else in the store. We looked out at the rain.

"Ten percent chance of rain, they say!" Ali exclaimed. "Ten percent! And this? What's this?"

"It's Oliver," I said to Ali, "Oliver letting us know . . ."

I didn't really believe it, but it felt good to say anyhow.

Ali nodded. "Yes, he saying, 'Everything good now.'"

Cars zoomed by, cabs, a police car, then another, red lights, sirens roaring. Ali shook his head, dismissively, and went on to tell me a story: "One night, I hear sounds—sirens—lights—and cops pull up right in front of shop. Right here, right there," he emphasized, pointing out at the curb. "I think, 'Nothing wrong, I don't call cops, what's happening?' But then police get out of their car and just walk into shop, and the policeman—she say to me—"

"It's a police*woman*?"

"Yes, woman policeman, and she say, 'I want to buy lottery.'"

Ali explained that it was one of those days when the jackpot was really high. Then he grinned and shook his head, like that was the end of the story.

"So, wait, let me get this straight: There was no emergency? Nothing wrong?"

Ali was blasé. "Right, nothing wrong, I do nothing wrong, I never do. She buy a bunch of tickets."

"So then what happened?"

"She played her badge number—won $200, and split it with her partner."

"Didn't even give you a tip?"

Ali looked at me like, *Did you just move here? Are you crazy?*

"No! Nothing! They get in their car, put sirens back on, and go."

I laughed for the first time in many days. "Thank you, Ali."

"You're welcome, my friend."

POSTSCRIPT

I once met a woman who was an astronaut—she'd been an engineer aboard the space shuttle and completed five missions. She told me that the coolest thing about life in space was not weightlessness or the incredible speed with which you travel, but the view of Earth from hundreds of miles away. You cannot imagine how beautiful it is. And when you're in orbit, the sun rises sixteen times a day.

That pretty much sums up how I feel about New York. I found I had to leave it in order to get a clear perspective on my life here and to write this book—most of which I did in Rome in a single five-week period less than six months after Oliver died.

One evening, I took a walk by the Tiber. I was going to take my usual route—across the Ponte Sisto and through the Palazzo Farnese—but changed my mind when the light turned green and headed west instead. I took a right on the Ponte G. Mazzini and stopped mid-span. Some people say Rome is a big, tough city, gritty, but I don't find it this way at all. (Have they been to New York?) I find Rome gentle, magical. The sun had just set, and the light was extraordinary—smoky-rosy-golden-violet, light that cannot be captured in a photo or, for that matter, in words.

I found a pen in my jacket and wrote a note to myself on a tattered map, the only thing in my bag or pockets resembling a piece of paper:

Living in Rome makes me wish I were
Living in Paris, which makes me wish I were
Living in Amsterdam, which makes me wish I were
Living in Iceland, which makes me wish I were
Back home.
New York.

Back home, I find that the one question I am asked more often than any other these days (the one question other than, *How are you doing?*) is, Are you going to stay? Are you going to stay in New York?

"By 'stay,' do you mean forever?" I mean to ask but don't. Stay till I die? Till I am too old to take care of myself, like my father?

"For now," is my answer, but I don't know, not really. If moving to New York at age forty-eight taught me anything, it is that I am capable of starting over in a new place. And yet, the thought of leaving it, of knowing how much I would miss, is too painful to contemplate.

I remember how Wendy once told me she loved New York so much she couldn't bear the thought of it going on without her. It seemed like both the saddest and the most romantic thing one could possibly say—sad because New York can never return the sentiment, and sad because it's the kind of thing said more often about a romantic love—husband, wife, girlfriend, partner, lover. You can't imagine them going on without you. But they do. We do. Every day, we may wake up and say, What's the point? Why go on? And, there is really only one answer: To be alive.

—New York, August 30, 2016

Under the Overpass

ACKNOWLEDGMENTS

GRATEFUL ACKNOWLEDGMENT is made to the John Simon
Guggenheim Memorial Foundation and the Leon Levy Foundation
for their very generous support of my work, and to Blue Mountain
Center and the American Academy in Rome for providing time and
space to think and write.

I am equally indebted to friends and family. Special thanks to my
wonderful agent, Emily Forland, and to her fellow agent, Emma
Patterson, both such wise advisers; to my editor at the *New York
Times*, Peter Catapano, who deftly edited several early pieces in this
book; to the *Virginia Quarterly Review*; to Steven Barclay—such a
big-hearted friend; to Jane Breyer, Paul Wisotzky, and Melaine
Zimmerman, for being there twice (and many times more); to Joel
Conarroe, Kate Edgar, Mark Morris, and Richard Rodriguez, for
their encouragement and support; to Lisa Garrigues, for her careful
read of the manuscript at a crucial stage; to Cindy Loh, George
Gibson, Alexandra Pringle, and the entire team at Bloomsbury in the
U.S. and the UK; and especially to my longtime editor and friend,
Nancy Miller, who has believed in my work from the beginning. It
is to her that I have dedicated this book, with gratitude. Finally, I
would like to acknowledge my first agent, the late great Wendy Weil,
who looked me in the eye one day years ago and told me I really
should think about doing a New York book.

A NOTE ON THE AUTHOR

BILL HAYES is the author of *The Anatomist*, *Five Quarts*, and *Sleep Demons*. He is a recipient of a Guggenheim Fellowship in nonfiction (2013–14) and a Visiting Scholar residency at the American Academy in Rome to work on this book. He is a frequent contributor to the *New York Times*, and his writing has appeared in the *New York Review of Books*, *Salon*, and the *Virginia Quarterly Review*, among other publications. His photographs have been featured in *Vanity Fair*, the *New York Times*, and the *New Yorker*. He lives in New York. Visit his website at billhayes.com.